Little Boxes

Little Boxes

12 WRITERS ON TELEVISION

Edited by Caroline Casey

Coffee House Press
Minneapolis
2017

Coffee House Press books are available to the trade through our primary distributor, Consortium Book Sales & Distribution, cbsd.com or (800) 283-3572. For personal orders, catalogs, or other information, write to info@coffeehousepress.org.

Coffee House Press is a nonprofit literary publishing house. Support from private foundations, corporate giving programs, government programs, and generous individuals helps make the publication of our books possible. We gratefully acknowledge their support in detail in the back of this book.

LIBRARY OF CONGRESS CATALOGING-IN-PUBLICATION DATA

Names: Casey, Caroline, 1976– editor.
Title: Little boxes : writers on television / edited by Caroline Casey.
Description: Minneapolis : Coffee House Press, 2017.
Identifiers: LCCN 2017021733 | ISBN 9781566894722 (paperback)
Subjects: LCSH: Television programs. | Television—Social aspects. | BISAC:
 LITERARY COLLECTIONS / Essays. | SOCIAL SCIENCE / Popular Culture. |
 PERFORMING ARTS / Television / History & Criticism. | ART / Popular Culture.
Classification: LCC PN1992.5 .L58 2017 | DDC 791.45/09—dc23
LC record available at https://lccn.loc.gov/2017021733

PRINTED IN THE UNITED STATES OF AMERICA

24 23 22 21 20 19 18 17 1 2 3 4 5 6 7 8

Contents

Introduction

Caroline Casey, editor

I once sat under a flowering tree—it was Iowa, it was probably crab apple—listening to a celebrated writer bemoan the deracination of our culture. Another writer, not known then, shot back, "I watch *Law & Order,* and that doesn't make me a bad person or a bad writer."

It was the greatest. I also watched *Law & Order,* and *Days of Our Lives,* and *Wings,* and *Magnum, P.I.* with an avidity that only those who grew up under a go-read-a-book regime can know. I had read so many books, but they didn't hit the same sweet spot that TV did: that fizzy combination of white noise and sugar rush. And though I was never going to be a writer, TV or not, I was going to be a book person who refused to believe that culture is a zero-sum game, or that delight and distraction in one form might swamp it in another.

While book people are too often on the back foot, defending reading against the latest cultural interloper—radio, movies, television, the internet—it turns out they also watch a lot of TV. In every publishing job I've ever had, last night's episode has come up more frequently than the last book someone's read. Maybe because we don't want to talk shop, or

maybe because television is built of familiar stuff: narrative, dialogue, scene-setting, rhythm—just close enough that we can appreciate a job well done, but far enough removed that we don't have to go deep on the mechanics. I don't know how a tracking shot works, but I can relish one without anxiety; the same cannot be said of any discussion of how white space is used on the page. And so *Little Boxes* was cooked up with one animating idea: what if television not only doesn't make you a bad writer, but makes you the writer you are? How could it not?

We had one parameter: everyone asked to contribute (including the now-celebrated smart-ass from my crab apple days) grew up in that finite moment when television was omnipresent, but before the internet was. Very special episodes and after-school specials, Lifetime movies, Nell Carter sitcoms, and home-sick reruns of *The Brady Bunch* and *I Dream of Jeannie*—whatever combination of influences we had, we had all come of age in the blue light of a cathode-ray tube. No one had just one show they wanted to write about, or just one idea; it was as if essays had been percolating for years, taking shape in conversations over drinks or long car rides, or as a form of procrastination from whatever project the writer was supposed to be working on. There were a few unsurprising overlaps (*My So-Called Life*, *The Cosby Show*) to iron out, and then: delight.

I should have known: good writers are always good readers first. Patience and close attention, two things writing requires, devoted to TV, the consumption of which requires neither. Sharp elbows, generosity, and ambition follow. A good essay noodles an idea from murk to surface. Race, envy, friendship, grief, music, mansplaining, outsiders and insiders—just pick your channel. They've found us, in all our mess, pressing against the limitations of our bodies, reveling in the ways we expand beyond them, doing what art does best: locating something human in the world.

Little Boxes

Naïve Melody

Elena Passarello

We got an Airbnb outside of Roslyn. The website showed only a half-dozen rooms for rent in town, all of them long gone when we decided to take our last-minute road trip. I'd only scanned the description of the one remaining rental in our price range, a "Tiny House Mountain Retreat!" that looked cozy in a rustic kind of way. Upon arrival, we discovered said "retreat" was actually the back half of an auto shop on the busy logging road to Seattle.

When we learned the place had no heat and that our toilet and shower were across a gravel parking lot, I couldn't help but think of the pilot episode. Urbanite Dr. Fleischman arrives in the middle of the Alaskan nowhere and tours the small cabin where he must chop his own wood, kill the rats that scurry under his bed and, by the end of the second episode, bathe in the freezing lake outside. Cue the music. Cue the moose.

"It's just for a night," my boyfriend said. We were driving to Puget Sound the next day. He suggested we dump our bag and walk the old mining road into town, maybe eat at the Brick, before it got dark. The

Perseids shower would be at its hilt that night and we hoped the light from the road wouldn't drown it out. The auto-shop owner stopped us on our way out the door and asked what had lured us from Oregon: biking? Fishing? Wineries? I felt sheepish to tell him the truth: *Northern Exposure.*

"That's how we ended up here!" he said. "We felt like movin' to the mountains, and this little town looked cool on TV." He was in his fifties, bald, with wide, friendly eyes and a motorcycle rally T-shirt. I could hear his shop radio through the wall: "Edge of Seventeen." It pleased me how unusual that choice of music seemed.

...

Northern Exposure's creators—the team responsible for *I'll Fly Away* and *Amazing Stories*—wrote, sold, and shot the pilot for their Alaska TV show without having ever set foot on Alaskan soil. They would later justify their lack of research with their vision. "We used Alaska more for what it represents than what it is," creator Joshua Brand told *Time* in 1991. "It is disconnected both physically and mentally from the lower forty-eight, and it has an attractive mystery." Ample space for the unexpected was key for Brand and his partner, John Falsey. This was the same creative team, mind you, whose show *St. Elsewhere* took place, as was revealed at the finale, inside a snow globe.

The invented town of Cicely is no stranger to magical realism. The citizens swap ids and hijack each other's dreams; they hallucinate and are as likely to break into song as they are to go fishing. In one episode, a lonely woman thinks her old lover is reincarnated as a dog. In another, a man dreams of riding shotgun in a big rig driven by Jung. Death is a constant but somewhat whimsical presence in their lives—when a septuagenarian receives a funeral plot for her birthday, for example, she relishes the opportunity to dance on her own grave.

Since filming costs were cheaper down south, all six seasons of *Northern Exposure* volleyed between a Seattle-area soundstage and Roslyn—a worn ex-mining town ninety minutes to the east where the show's exteriors were shot. Viewers in Anchorage or Ketchikan probably balked at the Cicely landscape, but when I watched the show in a

handful of suburban Atlanta living rooms, those streets—as well as all the kooky behavior that happened on them—seemed pure Alaska.

Northern Exposure's first three seasons collided with my early-teen babysitting years, when I was old enough to be out alone but still too young for any real social life. After my charges went to bed, I'd spend evenings curled on other people's couches, watching network television at a low volume and sneaking food from the fridge. A new independence came with this late-night babysitting, as well as a chance to muse on what my adult home might be like: where I would end up, what couch would be in my future living room, and what food would be in my fridge.

The two shows I caught the most were both Pacific Northwest–focused. Sometimes I wonder how much of the decision to move to Oregon in my thirties came from what I watched in my teens: *Twin Peaks* and *Northern Exposure*. Both programs are inextricably tied to their landscapes as well as to the music they include. *Twin Peaks* had a custom-built Angelo Badalamenti score running under everything, while each *Northern Exposure* episode collected a playlist of preexisting pop, jazz, zydeco, and country standards. Any given episode might treat a viewer to songs by Kitty Wells, Gary Glitter, Mozart, Ruth Brown, Mötley Crüe, or Talking Heads.

...

I didn't plan it this way, but our walk into Roslyn followed that of Mort, the adolescent moose that clomps through an empty Roslyn in the show's opening credits. Coming from the northwest, we hung a right at Village Pizza, strolling down Pennsylvania Avenue and looking for antlers nailed over the shops' doors. We spotted the blue clapboard building with DR. JOEL FLEISCHMAN still lettered into the window and then crossed the street, just as Mort did. The famous Roslyn Cafe mural ("An Oasis") rose up the brick wall to our right; it was all still there. I played the poky harmonica theme in my head as we about-faced, quitting Mort's path and heading east on Pennsylvania, toward the KBHR radio window display.

In addition to having no social life, I'm not sure how much of an aesthetic life I enjoyed at age thirteen. Though my slate was all but blank,

I did possess a dawning sense of how much there was to learn. With no older siblings and parents who only owned Christmas cassettes and the *Pretty Woman* sound track, I looked to TV and the college radio stations my boom box barely detected as curatorial fairy godmothers. I could wake in the middle of the night with my radio still playing WRAS ("Album 88: The Voice of Georgia State"), and a low voice might introduce three versions of "Tighten Up" back-to-back, then recite the liner notes to *A Love Supreme,* and then cue an old B-52s track. I kept a blank tape in the deck at all times and turned off the radio only when my mom made me. Sometimes I watched TV with a notebook in my hand so I could write down intriguing one-liners *(The owls are not what they seem)* or sound track lyrics that someone might identify for me later.

As a slightly lonely and definitely bottled-up kid, music was how my heart felt the most open. My preteen journals ignore any conflict in my life and instead just feature rhapsodic sentences on all the COOOOOOOL STUFF coming in on various airwaves and how desperate I was to be introduced to more of it. I know that in many bedrooms near mine, kids were finding the Cure and *Pump Up the Volume* to explore their moodiness, but for me, that came later. In the very early nineties, pop culture was my vehicle for optimism—all the imaginative stories and inventive sounds that I knew were out there, though not yet within my reach.

It makes sense, then, that I would adore the good-natured *Northern Exposure,* with its pretentious loners, allusive dream sequences, and significant attention to diegetic sound. The show even has a deejay woven into its ensemble: Chris, an affable ex-con-turned-sculptor and the sexiest Cicelian by an Alaska mile. The whole town listens to Chris— presumably KBHR ("K-Bear") is the only station for miles—and so as the events of each episode unfold and interweave, Chris's playlist for the town underscores them.

What's more, the characters use music to make unexpected connections. The eclectic nature of the KBHR playlist—the cultural gaps between the Django Reinhardt song beneath one scene and the Grandmaster Flash song in the next—often reflects the odd pairings of Cicelians who find themselves stuck in a plotline together. KBHR plays

"Moonlight Sonata" through Ruth-Anne's store while she warns Dr. Fleischman about Cicely's resident Bigfoot. "Who Put the Bomp" blasts from the doctor's clock radio the morning his snobby fiancée arrives. On Thanksgiving, Carl Smith's "Let Old Mother Nature Have Her Way" wafts through the Brick as Chris describes to Shelly, the waitress, the concept of *weltschmerz*—feeling the pain of something missing from your world even though you can't quite put your finger on what.

I now know Scorsese did this kind of pointed scoring a decade before *Northern Exposure,* but I hadn't watched *Goodfellas* yet; I was baby-sitting people's kids so they could go see *Goodfellas.* From the perspective of my small and uninformed life, *Northern Exposure* was the first piece of culture that loved music as much as I did, and it was so much smarter and worldlier than I was about it. A quarter century later, it doesn't feel like much of a stretch to remember the six seasons of the show as a sentimental education.

...

The tiny KBHR studio is in a window at the front of Roslyn's historic Northwest Improvement Company building. Its red neon call letters have been replaced with large blue posterboard cutouts that hang askance above Chris's deejay desk, which is pushed right up to the glass. Looking in at the set pieces with the twilight rising around us, I felt a wave of skepticism. This had to be a mocked-up revamp of Chris's office that some savvy town commissioner collected from local junk shops to lure TV nostalgics like me. I got the sense that this KBHR was like a holographic Tupac, or something akin to the giant rebuild of Skylab that the Smithsonian built to try to fool us into thinking the space station didn't fall to earth the year I was born.

It turns out all those props were indeed authentic, but I still wasn't looking at the real KBHR. Just one year before, an Ellensburg flower shop rented the window that was used in the show, so the Roslyn Downtown Association reassembled all the dusty props the next window over. I find it even stranger that this wasn't a fake KBHR, merely an off-center one. KBHR had shifted just enough to place an uncanny tension in the back of my mind.

"Let's go get a drink," my boyfriend said, and we turned away from the window.

...

Though I've rewatched *Twin Peaks* a few times since its original airdate—the series has been streamable for years and my college even had a student club that screened it—I've never revisited *Northern Exposure* all the way through. A decade ago, I got ahold of some DVDs, but I couldn't finish them. Something about the episodes on DVD produced a displacing vertigo. The show felt slower and more disjointed, like the characters encountered the stories at arm's length. Gone was the thickly woven feeling of one scene tumbling into the next.

One episode, "Slow Dance," I remembered vividly from back in the day. A minor character dies in a freak accident when a rogue satellite crashes into his campsite. In a black humor characteristic of the show, Dr. Fleischman and company can't untangle his dead body from the equipment. His funeral is typical Cicely—silly, inappropriate, and wistful. When the pallbearers arrive with the coffin, a dozen metal telemetry monitors and antennae sproing out of it. The church explodes in laughter at the sight of the unwieldy casket, while the deceased's girlfriend, Maggie, the bush pilot, moons in a pew.

On the DVD version of "Slow Dance," the scene is underscored by canned, wordless music—a synthesized klezmer swing tune that makes the funeral sound as if it's happening inside an elevator. The original sound track has been removed from the DVD. Underneath the action, Chris is supposed to play Peggy Lee singing the conflicted verses of "Is That All There Is" as only her voice can. That mixed-up, wry song is a perfect choice for this goofily macabre scene; it's what makes it permissible to laugh at a dude's coffin. Except now, where Peggy Lee once was, there is essentially nothing.

"That was one of Rick's favorite songs," Chris says when he stops the muzak.

...

Of the dozen songs in the "Slow Dance" episode, all but three have been replaced with canned music. When retired astronaut Maurice waxes about Rodgers and Hammerstein, "Oh, What a Beautiful Morning" is still there. And the closing scene—of Joel waltzing Maggie around the Brick while "At Last" plays on KBHR—uses the Etta James version we all know. The nine missing songs are, sadly, the more obscure music that would have sent adolescent me running for my notebook: Percy Faith, Hortense Ellis, the score to *Juliet of the Spirits.*

Without their adhesive connections, the teleplay dims considerably, like a gallery tour that's lost its guide. One superfan expressed a similar sentiment when a trade magazine interviewed him about the DVD releases. "It feels like a character has been deleted out," he said. "What if they didn't want to pay [actor] Rob Morrow's residuals and whited him out and computer-animated someone else in? You wouldn't say that that was the original series."

In what has become a common story, Universal Television negotiated licensing only for *Northern Exposure*'s broadcasts—unaware in 1990, perhaps, of the forthcoming boom in home entertainment. A decade later, when fans demanded to see Cicely again, there was no way to both pay royalties to each episode's myriad songs and sell the DVDs at marketable price points. Plus, these releases were rush jobs. Universal didn't have time to sleuth out clearances for the songs whose publishers had changed hands or whose rights had been renegotiated. If obtaining a song's rights was a hassle, they surrendered that moment to their in-house composers and then moved on to the dozen other tunes that needed clearance. This is why "A Whiter Shade of Pale," which spent the first ten years of this century in intense litigation, is missing from its crucial Cicely moment in season 4: another funeral, but this one with a coffin and a catapult.

Some episodes are more intact than others. Universal managed to clear both Hendrix's "Hey Joe" and the novelty hit "Pencil Neck Geek" for the Edgar, the taxidermist, episode in season 5, as well as half the other KBHR songs that play in the Brick for that story. But the famous *Wizard of Oz* episode from season 3 is a total gut job, with nearly all the tracks, including "Over the Rainbow," missing.

The replacement that really kills me is the "Dinner at Seven Thirty" episode—a forty-minute fever dream that recasts all the characters as unhappy New Yorkers. On DVD, the show begins and ends with the same bullshit faux-reggae number. When it aired, however, the wild episode was bookended by the exact opposite sound: Talking Heads' singular "This Must Be the Place (Naïve Melody)." I think "Dinner at Seven-Thirty" was my first encounter with that perfect song, and I hate that it isn't there anymore.

...

Northern Exposure isn't the only old series to sideswipe fans with replacement music. It's happened enough that I can identify the discovery as a branded feeling inside me. Neither *Quantum Leap* nor *The Wonder Years* sounds like it used to, and all my beloved MTV shows from the nineties that were chock full of music—*Daria, The State*—have since lost much of their sound tracks. I recently rewatched a *State* sketch I must have seen fifteen times in high school—Michael Ian Black's toothbrush dance. "C'mon, toothbrush!" he says in both the original and DVD versions of the sketch. "Let's go run around and do things while popular music plays!" But in 1994, he and the toothbrush ran around to an actual popular tune: Sugar's "Your Favorite Thing." Twenty years later, the pair cavorts to a bunch of rip-off, Sugar-esque power chords and nonsense lyrics about how "all the kids are coming down."

It's not that this dumb replacement music cheapened Black's toothbrush dancing; the music in this sketch is pretty insignificant. What stings is the fact that I could still hear the Sugar song as I watched the DVD. That song belongs to an earlier version of viewing—an earlier me—which the revised sketch proves I can no longer access. *Northern Exposure* now does this too, in addition to feeling cheaper after the loss of so much well-chosen and evocative music. The lacuna between the two versions of myself is now on the TV, and it is a tense and ultimately unnamable thing. It's some mix of itchy nostalgia, the panic of aging, and the confrontation of loss. A kind of aural *weltschmerz,* maybe.

...

Universal did try to maintain *Northern Exposure*'s intended sound. The initial DVD release of the first season cleared all the original music, but it sold in stores for $60, or $7.50 per episode. At that rate, purchasing the full six seasons with music included would have cost a viewer over eight hundred dollars, so subsequent DVDs were never sonically correct— only season 1 remains intact.

But like the beginnings of many series, these early installments of *Northern Exposure* still struggle to find their footing. The season suffers from its shoestring budget, and the cast, writing, and design obviously haven't gelled yet. Each episode offers only inklings of the texture and kooky confidence that the award-winning seasons offer. What's more, season 1 goes easy on the music. The sole exception is "Aurora Borealis," the last episode on the disc and the first *Northern Exposure* episode to bang its sound design like a fist on the table.

"Aurora Borealis" covers three nights when the moon is so large and bright that nobody in Cicely can sleep. Ruth-Anne's store runs out of Sominex and the clientele at the Brick is too edgy for breakfast. Rumors circulate that Adam, the Bigfoot, is sneaking into houses to steal kitchen appliances by moonlight, and a mysterious stranger rides into town having driven all night from Oregon, following the moon and an odd dream from childhood.

As these plotlines twist into one another, KBHR plays a run of great lunar tunes, starting with the cold opener. While Chris monologues on-air, Louis Armstrong's indelible voice sings "Moon River" and the camera pans across the luminous sky. The scene fades into the title credits right at the moment Armstrong stutters the lyric "two drifterssss," and the combination of the light and Armstrong's sibilant breath and Chris's opening monologue is magic.

Armstrong's trumpet version of "Moon River" pops up other places in the episode, in which the Cicelians toss and turn, the doctor has a run-in with Adam, and Chris discovers a psychic connection between himself and the Oregon newcomer. We also hear strains of the "Moonlight Sonata" (both regular and disco versions), CCR's "Bad Moon Rising," Billie Holiday's "Blue Moon," and the classic "Mister Sandman," though the Chordettes' sweet voices turn eerie when the show pipes

the song into an off-kilter dream sequence. Then the episode ends with Armstrong's voice once more—"two drifterssss"—and that perfect Satchmo hiss.

Seven years after it aired, *TV Guide* named "Aurora Borealis" the sixty-fifth-best episode in American broadcast history. I just rewatched it, and I can't imagine it capped with any sound other than Armstrong's daffy baritone. To spackle in some anonymous Casiotone foxtrot with a canned horn is just as unthinkable.

"Aurora Borealis" also perfectly displays why music is so crucial to this show. Cicely is a wonderland, a place of nonreality, but its music is real and accessible; you might one day turn on your radio and hear any of the eccentric moonlight tunes on some local underground station. Those weird but available songs tether us to the fancies of the show—or rather, they put us within reach of the show's otherworldly magic. Maybe that's exactly it: the music reassures the viewer that Cicely is a real place they could visit if they ever needed to.

...

The Brick Saloon of so many *Northern Exposure* exteriors is actually the oldest bar in Washington, founded in 1889, just three years after Roslyn's incorporation. With a running water spittoon, a century-old basement prison, and a huge wood-carved bar imported from Ireland, the tavern offers plenty of actual history to counter the TV trivia we'd been hunting. Strangely, though, it also felt the most like Cicely of any spot we visited. Sure, the layout was different from the soundstage interior of the Brick, but it carried the same dim and friendly vibe. Toward the phone booth in the back, three generations of a family played shuffleboard on a warped table, and the french fries coming out in baskets from the kitchen smelled incredible. We took a seat at the bar and ordered two Jacks with Bud backs from a bearded man with a Tennessee accent.

Though he's never seen the show, my boyfriend is much more of a Cicelian than I am. He'd happily let a magical subreality hijack his life. I fell in love with him for his independence, his record collection, and because weird things often happen when he's around. That night at the Brick was no exception. A few sips into our beers, we noticed

the woman on the stool next to him—a bubbly redhead dressed in mismatched prints with a green Quaker parrot perched, unleashed, on her finger. We looked around; nobody stared. It seemed a given that this woman would spend her Thursday pounding sweet tea vodkas at the Brick with her exotic bird.

When my boyfriend asked her the parrot's name, she immediately plopped it onto his shoulder. It spent the next half hour crawling around his collar, up and down his arm, even onto his head. When I tried to get it to come over to my hand, it bit me.

"He has his favorites," the redhead shouted. Her drink and her bird were the exact same color.

She then launched into a breathless account of her stint that evening at the town open mic, presumably singing duets with her parrot. Some burly lumberjack type in the audience balked at her bird, so she called him a wussy from the stage. When other burly dudes at his table proceeded to heckle her (and her little bird too), she fled from the open mic to meet her man, who had just finished his kitchen shift at the Brick. Said man was a good twenty years her senior and sat five bar stools away from her. We couldn't tell for a while if the two actually knew each other, but within the hour, they were sucking face back by the shuffleboard table. By then, the parrot had disappeared altogether, though neither of us can remember it quitting my boyfriend's shoulder.

We also can't remember any music. Something must have played through the Brick's speakers through all this drama. Were we actually in Cicely—not the DVD version, but the Cicely of my youth—this would have been a classic KBHR moment, the perfect tune zapped into the Brick from the studios one block down the street. Perhaps it could be some tune that once belonged to the real show, but has since been extracted on DVD—one that underscores the bird on my boyfriend's shoulder, the glowering french-fry cook, and the woman yelling parrot baby talk down the bar. A perfectly unexpected *Northern Exposure* melody that would make the whole bar stand up, partner off, and slow dance.

Imagine Brian Eno's "Lay My Love"—from the episode when Chris and Ed teach a whooping crane its mating dance—as the woman's little bird burrows in my boyfriend's hair. Or that ultimate jock jam, "Rock

and Roll Part 2"—used in a season 5 fireworks display—as the redhead knocks her drink into her purse. Or *Blade Runner*'s eerie love theme, which played after Dr. Fleischman's drunken tryst with Maggie, as the bird flies past the shuffleboard table and out toward the patio. Or perhaps, even, the perfect "This Must Be the Place" as we pay the bartender and head back to our cabin behind the auto shop.

The fluffy keyboard line yields to David Byrne's surreal tenor as my boyfriend opens the Brick's heavy door. Cicely, Alaska, becomes a sidewalk in Roslyn as Byrne sings "I love the passing of time." We walk past Village Pizza and up First Street to him crooning "if someone asks, this is where I'll be." And as the song ends with Byrne in full howl—"I'm just an animal looking for a home!"—a green bird flies over our heads. We watch it flap over the wall with the "Roslyn Cafe—An Oasis" mural, and my boyfriend slides his hand into the back pocket of my jeans. Just as the bird flies out of our eyeshot, the Perseids begin their silver streaks across the northern sky.

My Monster

Edan Lepucki

What I remember: a dead girl wrapped in plastic and another one half-alive and stumbling along train tracks, her body covered in cuts and bruises, her clothes torn. Letters tweezed from beneath fingernails. The dead girl, blue-white like a vein. Her name is Laura Palmer. There's also a lady cradling a log and a beautiful woman who knots cherry stems with her tongue. Handsome Agent Cooper with his hair slicked back. The name Peggy Lipton lingering across the screen as the eerie theme song sluices through my veins.

...

I was nine when *Twin Peaks* first aired and eleven when the follow-up, *Fire Walk with Me,* was released in theaters. I didn't see it. I'd already been sufficiently traumatized by the show, though I didn't yet have that word for it. And at thirty-six, I'm still a little afraid. When it was announced that a new season would be filmed for Showtime and the internet filled with images from the series, I felt my old cowardice. I was also pissed. *Twin Peaks* fucked me up for years, but most people my age

waited until they were adults to watch it, and now the show has become another credential of cool, à la preferring season 2 of *The Wire*. Any well-dressed intellectual with a sense of humor has seen *Twin Peaks* and loves it, and I have to wade through their fandom every time I go online, my eyes squinted against the horror.

...

The show premiered a few months before my mom became pregnant with my half sister, Sarah. By then my oldest sister, Lauren, had been living full-time at our mother's house for at least a year, maybe two. She was fifteen and no longer speaking to our dad. My other sister, Heidi, and I were still doing what we'd done since 1985: moving between our mom's and dad's houses every Monday per the custody arrangement. They were divorced by the time I turned five, and the only day of their marriage I remember is the last: how they sat across from each other in the bathroom, discussing their separation as my sisters and I ran in and out of the room.

I was at my mom's house the first time I saw the show. I remember going downstairs to see what she was doing. She lay across her king-size bed, watching TV.

"What's this?" I asked

"It's new."

In my memory, my mom doesn't remove her eyes from the screen, where a teenage girl in torn clothing stumbles along train tracks. A man dressed like a lumberjack rescues her.

The scene transfixed me—*that poor girl!* I sat on the floor in front of the TV and stayed there until the credits rolled.

I sometimes ask myself why my mother would ever let her nine-year-old daughter watch a show that clearly wasn't intended for children. My dad was the more permissive parent. He didn't make me take a bath if I didn't want to, didn't make me clean my room, didn't make me go to bed early. If he had a comedy gig, he would leave me and Heidi alone, no matter how late it was. He never hired a sitter, not even in the summer: during those months, we roamed the neighborhood alone or watched TV with the curtains closed or roasted marshmallows over

the stove for a snack. My mom was appalled by all of this, and yet she let me watch *Twin Peaks* when I was only nine. Would it have been more excusable if I'd discovered the show one evening by myself, at my dad's?

I wonder if my mom even registered I was in the room. She had three daughters to keep track of, after all, and she was working full-time. If anything, she probably took my emotional temperature, saw that I wasn't freaked out, and figured I could handle it.

When Heidi, two years older, heard I'd watched the first episode, she insisted she start watching it too. Lauren did as well, but with so many televisions in our house, we didn't gather around a single one. *Twin Peaks* didn't have the power to bring us together, not like *Beverly Hills, 90210* would a year later. In my memory, I watch the show alone or with my mom. We're in that giant bedroom of hers with its granite fireplace, above which hangs an ugly painting of a naked woman with floppy breasts. When I ask my mom why she likes the painting, she says, "It makes me feel better about myself." When my mother makes a joke, she giggles like a girl.

I must have watched *Twin Peaks* at my dad's house too. I'm sure I did, but I don't remember. In fact, I don't remember watching any of the seminal shows of my adolescence at his place. And yet, so many of my memories of his house are of the television. It was always on.

...

My mom's: A three-story modern house in the hills overlooking Los Angeles. Clean as a museum. Home-cooked dinners at the kitchen table every night. Eventually my half sister, Sarah, is born, and then my half brother, Asher. Baby seat on the counter and baby wallpaper in the nursery. Televisions in two of the four bedrooms, and in the den, a huge set as tall as I am. At night everyone goes into their rooms and shuts their doors.

My dad's: A small Spanish-style rental ten minutes down the hill. Steak with instant french fries for dinner every Monday. Homework in front of the living room TV, dinner there too. A second, tiny black-and-white set moved from the kitchen to the bathroom and back again, to

watch while cooking and bathing. Dad going out at night to do comedy. His various girlfriends lasting varying amounts of time.

Twin Peaks: A tiny town with big, tall green trees and a big rushing waterfall. To a girl like me, born and raised in L.A., it's the kind of place that exists only on TV.

...

The show was eerie from the beginning, and Bob, who was a straight-up demon but resembled a man with long gray hair and wicked eyes, truly scared me. But I also loved its crime-solving elements, and I quickly developed a hopeless crush on Agent Cooper. (In the sixth grade, I forgave my friend Lana for some forgettable transgression when, as a kind of olive branch, she set a framed photo of Kyle MacLachlan on my desk.) Before Agent Cooper, I'd been in love with Doogie Howser, M.D., and before that, Alex P. Keaton from *Family Ties,* and before that, Radar from *MASH.* It seemed for all my life I'd been half-living in one television series or another. *Twin Peaks* was my latest world, despite its scary parts. Or maybe because of them.

The fear didn't get its claws into me until the day Heidi returned from a trip to the Beverly Center, a nearby mall. We were at my dad's house that week, and in my mind, it's just the two of us, talking in whispers. If my dad is there, he's in another room, far from our girl drama. Heidi and I weren't friends, we barely got along, but that day, she wanted to talk and I was willing to listen.

"Bob came to me," she said. "I was in line at Contempo Casuals."

"What do you mean?" I asked.

"His spirit tugged the shirt I was planning to buy, and it fell on the floor," she said. "He entered me, Edan. He was inside my body."

"He was?"

"He's here now," she said.

Any other time, I would have used Heidi's rare display of vulnerability to gain power over her. But she looked so spooked and desperate that instead I tried on some kindness.

"It was just your imagination," I told her. "Don't worry."

She nodded, as if willing herself to believe me, but later that night, she crept into my room and shook me awake.

"Can I sleep on the top bunk?" she whispered. She used to sleep up there, before Lauren moved out and left Heidi a perfectly good room all to herself.

"Why?" I asked.

"I'm scared of Bob. He's in my room."

This time, I was just as frightened as she was. I told her O.K., *fine,* but everything felt wrong as she climbed up the bed's metal ladder.

It wasn't just Heidi I had invited into my room, it was Bob too. With a *whoosh,* he entered me. I felt him nestle into the black at the very back of my heart.

He was still there the next morning. In my memory, it's a Monday, and Bob drags me down like a hangover as I pack for my mom's house. My life has changed: I've been possessed. I don't dare say anything to Heidi, who seems unfazed by her nighttime fears, our previous intimacy burned off like cloud-cover. Who else can I tell? No one will understand. Bob's presence is a bleak feeling, but it's only that, a feeling. I can prove nothing, explain nothing, and so I shoulder the psychic burden alone.

Even though Bob entered me at my dad's, his presence is stronger at my mom's, where the house is large and dark and on a mountainside. Nights there, I close my eyes and see his evil grin, his scraggly hair. Tall trees surround his face; we are in the woods of my mind together. One night I feel him in the loft beyond the bedroom I share with Heidi. I imagine him sitting on an ottoman a few feet from our door. His legs are crossed effeminately, and he drinks a cup of tea. He is waiting there, witnessing.

Worse than these images, though, is the dark feeling that he is caught inside of me. He has left Heidi's body for mine, and he will stay forever. I carry him everywhere, certain that he has damaged me irrevocably.

Eventually, Heidi will announce that she's too afraid of *Twin Peaks* and begin a fierce fandom of *Wings.* I, on the other hand, bravely keep watching the show. I feel Bob luring me to it. He wants me to see it, and I have to obey. But my decision is borne out of stubbornness too. I

define myself in opposition to my sister: she likes hot dogs, and I like hamburgers; she likes to wear pink, and I, blue; she is pretty, I am smart.

She's afraid of *Twin Peaks,* and it doesn't bother me one bit.

(Not long after, Heidi will write our dad a letter, explaining that she will be living full-time at our mom's, just like Lauren. There's this then too: Heidi chose our mom, and I chose our dad.)

...

Bob stayed with me for years, long after *Twin Peaks* went off the air. I remember turning fourteen and thinking, *Bob's been in me for over four years.* By then, my fear was less alarming, more of a background hum, barely there but menacing all the same. I still believed in the possession. I knew, intellectually, that he was fictional, from a television show, but he was so keenly a part of me that he had to be real. He was David Lynch's creation, sure, but he was my monster.

A few years later, when Lauren was doing speed, my mom explained it to me and Heidi by saying, "It's what David is addicted to on *90210.*" For us, television wasn't merely a way to pass time, it was instructional. We adopted its stories as our own.

When Bob possessed me, all the darkness in my world funneled into my body in the shape of him. But it was also, in this way, contained. I was nine, and there were the two lives I led: the one at my dad's and the one at my mom's. There was the new baby girl my mom was going to have. And there was the moment Lauren walked up to my dad's car and told him she wasn't getting in and my dad drove home without speaking.

At the time of Heidi's possession, she was struggling at school; boys would make fun of her, call her a slut, or tell her she looked pregnant in a dress. What did Bob do for her?

Bob is also our dad's name. Maybe when Heidi stopped talking to him, she rid herself of the monster.

...

Last month, I went to the video store. I didn't want to stream *Twin Peaks* online; I needed to watch it in my living room, with my husband, on our TV, like people did in the 1990s. I rented the pilot three different times

without viewing it and racked up a bunch of late fees. I kept putting it off. I didn't want to have nightmares, and part of me was honestly afraid I might start believing in Bob again. But we finally watched it, on my husband's insistence, and even went on to view the first two episodes.

I was fine. I'm fine.

The theme song still has its foreboding effect, but now I'm able to recognize that it's a synthesizer paired with a bass. By the third episode, I named the instruments aloud, in wonder, and my husband laughed because I had announced the obvious.

I hadn't remembered the cheesy jazz sound track that plays during some of the more lighthearted scenes. I'd completely forgotten about Lara Flynn Boyle, whose beauty almost pains me it's so unassailable, and I'd never noticed what a fool Agent Cooper is: exclaiming over the town's trees, segueing from corpses to doughnuts with the graceful gracelessness of a professional crime fighter. I remember Bob being an old man—he's probably in his forties.

I understand so much about the show that I didn't as a girl. That it mixes a number of common narrative tropes, for instance: the crime story, of course, with its dead girl and the detective assigned to the case; but also the soap opera, with its close-ups of teenagers kissing desperately; and the slasher film, with its handheld shots of running through the forest. Not to mention the goofball vignettes of small-town eccentrics. It's Hitchcock in clown shoes crossed with supernatural unease. Like other David Lynch work I've seen, the story resists interpretation: it's a pastiche of tone, and the moment you've constructed a way of understanding it, you're thrust into a dream room with a dancing little person and a one-armed man who's broken the fourth wall to tell you about Laura's murder. It's deranged. To think it was on network TV!

I get why people like the show. The death of Laura Palmer is compelling because it's meaningful; it's deeply horrifying and alarming, and the supernatural threats defy closure and safety, which makes them all the scarier. But Laura Palmer's death is also a cliché, it's also campy, and the show balances these competing tonal registers without trouble. In the pilot, for instance, there's a prolonged shot of the staircase to Laura's bedroom. It's so stylized it's almost comic. It's also lonely and

desolate and scary. It's all that at once. At nine or ten, I couldn't have understood that *Twin Peaks* was aware of itself as artifice, because artifice didn't exist for me, not yet. Nor did self-awareness. Tropes don't work for the viewer who is experiencing everything for the first time.

I never discarded Bob, the idea of him, once and for all—there was nothing so dramatic and triumphant as that. Instead, his presence grew less and less central, less powerful, as I got older. The whole thing began to seem childish and unbelievable and, finally, funny. In a way, Bob was my first fictional character, and eventually I was able to say that at parties to make people laugh.

...

When I watched the pilot, I made sure I had a glass of wine and a piece of chocolate pilfered from my son's Halloween stash. My husband sat at the other end of the couch, my feet propped on his lap, and our tiny white dog lay panting on the throw pillow next to me. Occasionally I bent down to sniff the space between the dog's eyes, the place my husband calls the "stink face." I checked my phone a few times, and sometimes I paused the show, to get a glass of water or go to the bathroom. With every moment, my adult gaze diluted the power *Twin Peaks* once held over me. I was relieved, and a little melancholic too. Long ago, I had been utterly immersed in this story.

Now, my husband makes a joke about an actor's haircut, and we discuss how much thinner television sexpots are these days. Our television screen is streaked with our son's fingerprints. At my dad's, the small black-and-white hadn't been much heavier than my school backpack. It had its own special spot on the kitchen counter, and when I moved it to the bathroom, I had to turn up the volume to hear it over the running faucet. At my mother's house, the ceilings were so high, and the den had no door: it faced a spacious living room, big as a bowling alley, and dark. When Bob flashes across the screen, I grab my husband's hand and squeal. My husband tells me it'll be O.K. Our TV is centered atop an old IKEA credenza whose particleboard sag annoys me nightly. At my mom's, the city glittered far below. My dad's house was down there too, somewhere. My husband is right. It's not scary anymore, it's just O.K.

Lovewatch, Hatewatch
(or, "I Brought You into This World, and I'll Take You Out")

V. V. Ganeshananthan

For a long time, when people asked me what television shows I liked, I had only one show from which to choose. As a kid, I wasn't allowed television on weekdays, but my parents made *The Cosby Show* the sole exception. It was not only permitted; it was pretty much a requirement. I was more or less fine with this, or at least this is what I recall. Without fail, on Thursday nights at 8 p.m., Ganeshananthans assembled to watch Huxtables, and I loved it.

What made my parents choose *Cosby* as the exception to their rule about television, which they considered generally useless? Maybe it was that the Huxtables weren't white, as my family is not; we are Tamil, and Sri Lankan, and American, not always in that order, and had no prayer of seeing a family demographically like ours on the small screen. (This is still true.) But we could throw our allegiance to Cosby's fictional black family and see some things that we recognized. Maybe it was that Bill Cosby as Cliff Huxtable was a doctor, like my father; perhaps it was that lawyer Clair Huxtable was a strong and intelligent and opinionated and beautiful woman, like my mother. There is also more than a chance that

we saw my brother in goofy Theo, the only Huxtable boy among five children. Or maybe I was the recognizable one: before I went to college with Felicity or high school with Dawson Leery, I was about the same age as the youngest Huxtable daughter, Rudy. (I suspect it would be a lie to say I was as incessantly cute. In fact, I was definitely jealous that I wasn't.)

Compelling as all these factors were, though, none of them could have won my family's viewing loyalty without the necessary, indefinable, and joyous chemistry between the show's seven (!) leads. I was comfortable with the Huxtables' safe, upper-middle-class, black professional identity, sure, but more than that, I was comfortable with their comfort with each other, a dynamic that to this day I have never seen rivaled in a sitcom. They were more than merely funny and physical; they were also unapologetically and intelligently weird and quick and particular. As a child, I had only a subconscious interest in the representation of people of color on screen; I did know, though, that I craved Huxtable-level familiarity, humor, play, silliness, and wit. They felt, from their very first season, their very first episode, rich and real—wholly imagined.

The small intimacies and inside jokes of their family were irresistible on-screen. In Clair Huxtable I saw a wife and mother who let her partner lean on her, and I don't mean metaphorically. A Huxtable daughter receiving a scolding was likely hearing from parents entangled at the foot of her bed like cats; Theo entering the living room might find Cliff and Clair lounging on each other on the sofa. Even as the dapper duo jointly chastises their children, the attraction between them remains magnetic and undeniable. In one episode, Theo gets in trouble with the police for riding in a car driven by a friend who only has a permit—but his parents are bickering, and he hopes this will help them forget to punish him. To his dismay, he returns home one afternoon to find them on the couch, clearly about to make out. *Go upstairs,* they coo at him, staring at each other in reconciliatory delight. *We'll be up to punish you shortly.* Theo vanishes as instructed, and the couple discusses possible penalties while Cliff buries his nose in Clair's neck. Cosby's sparring partner, the indomitable Phylicia Rashad (née Ayers-Allen), is a notably gorgeous woman, but more importantly, the writers made the character

of Clair smart and sexy. She wants her way and mostly gets it, while her husband makes eyes at her.

The house of the Huxtable family seems to rest on this foundation. The magic of Clair walking into her own living room after a long day at work, only to see Rudy upended on her father, both of them asleep! *I have no idea how we ended up like this, dear,* Cliff Huxtable says when she wakes him up, and it seems innocent and sweet. *Don't wake her up,* Clair cautions him. Shaking his whole body, he demonstrates that it would be impossible to do so.

We trusted Cosby; I too could have fallen asleep there, believing completely that nothing bad would happen to me.

...

It's impossible now, watching this show, to see it without the invisible but insistent subtitles of my jaded heart. When Cliff Huxtable whirls Clair around, I imagine a chorus of women next to her. When he emerges from his OB-GYN practice, I wonder at his profession, which involves closely examining women's bodies even as it gives him the safe veneer of someone interested in the lives of children. When he polices his daughters' behavior or hassles their dates, I am distinctly unamused. Some people may be able to separate the artist from the art, and I don't know that I hold that against them. But I loved *The Cosby Show* because I found it intimate, and in the face of recent knowledge, that intimacy feels newly dangerous. As a kid watching *The Cosby Show,* I imagined my body in a space with their bodies—a safe and loving space. Today, as I rewatch, one person in that half hour seems sickeningly unsafe.

We know now that some women entering Bill Cosby's real home say they were in danger. He has been accused of drugging and assaulting them. The intimacy I admired in the show as a child and thought a signifier of safety seems to have been turned to his advantage when he wanted to prey on women who sought his professional guidance and mentorship. Armed with his avatar, Cliff Huxtable, Cosby wasn't silly; he was vicious.

Going back in time and television to think about why I loved this family so much, and why I felt they had been taken from me, I found

a YouTube clip of that same conversation from the pilot between Theo and Cliff. Someone has reedited it so that it involves Theo asking his father for a definition of sexual assault. I couldn't finish watching. I clicked away, away, away, so that I was no longer in Theo's messy teenage bedroom, no longer watching his authoritative, kindly father at the foot of the bed. I thought of the women and their stories.

...

Family and dear friends: the people in whose homes or upon whose shoulders you might doze off in complete safety, and without them minding. (Even now I am given to these lapses at the houses of favorite pals.) I think too of the comforting proximity of my own parents, who let me doze on them, in cars, at concerts, on planes, at people's houses, always gently chiding me to remove my glasses first so that I didn't break them. To me, the physical familiarity that was such a vital part of the Huxtables' undeniable fun looked dear and close and warm. I recognized it, perhaps because I often watched the show snuggled up on one parental shoulder or the other. And like the Huxtable children, when I was small I often looked for an excuse to clamber into my parents' bed. On other sitcoms, children snoozing near parents are astonishing, and played almost exclusively for comic relief. I can't wait until the kids are out of here, the parents say to each other. Or: Now we can have fun. But on *The Cosby Show,* a stray child diving into the bedclothes is routine, and Cliff and Clair obviously sometimes want their children there. The physicality of being related is present in every single scene.

The pair often counsels their offspring as my parents did, inviting them to have private conversations that give the young people a modicum of dignity, even when they misbehaved. Admonishments are often paired with reminders of love. Here in their implausibly spacious Brooklyn home is a set of siblings who kiss their parents hello, annoy each other, throw food at each other, borrow each other's clothes with and without permission, and hug. In early episodes, youngest siblings Rudy and Vanessa are at each other's throats; second sister Denise admonishes her mother to control her children when they begin a fight at the dinner table. But Vanessa and Rudy also wander around the

Huxtable household with entwined fingers as they bother each other. Theo gets in hot water when playing circus with Rudy results in her getting injured. This friction of love on the show felt—and feels—genuine and electric. The rub of affection and argument made possible all sorts of tender and difficult and odd conversations. The Huxtables were not only blacker but also smarter and stranger and more specific than other television families. More believable. Watching them is like being invited to a private club.

Their jokes are often deeply character-based. They favor family stories or mannerisms or imitations; they construct elaborate pranks, skits, and musicals. They can easily put on and shed other skins because their basic knowledge of each other is so strong. In one episode, Cliff imitates a car Denise covets; in another, he compares a woman giving birth to a toaster ejecting bread. But such hilarity wasn't Cosby's sole responsibility: the child performers with whom he surrounded himself would often rise to meet him in inspired performances that matched him silliness for silliness. Theo and Rudy are especially good at this. In the first Thanksgiving episode, Cliff mimics Julia Child while teaching Theo how to carve the turkey. Theo asks Cliff, "Why are you talking like that?" "I have no idea," Cliff says in response. "It just makes me feel more secure when I'm in the kitchen. Now try it, my boy. And talk it through." Malcolm Jamal-Warner as Theo doesn't leave the invention to Bill Cosby; he responds by creating his own growly Muppet-like voice, a character he holds even when his mother and sister dip their heads into the room to find out what's going on.

In the most famous scene from the pilot, Cliff explains to underachieving Theo why he will need to go to college by setting up a dummy life with a dummy job and a Monopoly salary. The money is quickly eaten up by rent, transportation, and food. (And taxes! As Cliff informs his son, the government comes for the regular people first.) Theo, who had said he wanted to be a "regular person," ends up with no money at all. He later tells his father that he understands his parents' point, but that they should understand his. They are successful professionals, but maybe he was just born to be a regular person and they should love him anyway because he's their son.

The studio audience claps a bit at this line masquerading as deep truth. This is where most shows stop, on the feel-good moment. But Cosby went for feel better. Cliff breaks back in. *Theo*, he says, that is the dumbest thing I've ever heard, and you are going to try hard at school *because I said so. Also, Theo, I love you. I brought you into this world, and I'll take you out.*

Later still, the whole family conspires to teach Theo a lesson along similar lines, but on an even grander scale. With Cliff, Clair, Vanessa, Denise, and Rudy in special roles—landlord, building owner, restaurateur, modeling-agency secretary—they perform a "real world" to give Theo an idea of what it's like to pay rent. When he laughs at their performances and asks for his family, they withhold their familiar selves from him. With its swift elevation of children to powerful status, the episode highlights exactly how little they know about how the world works. Rudy, ridiculous in an old-lady outfit, owns several buildings, and won't make any exceptions to allow her brother to rent an apartment. Cliff, playing the role of a building super, tells Theo— aghast at the sight of his bedroom bereft of furniture—that he needs a reference, and will have to get his own replacement bed and chairs. Theo slowly rises to the dare, enlisting his friend Cockroach to join the pretend world as his boss.

In another episode, Vanessa fights with classmates who call her a rich girl. "None of this would have happened if you weren't so rich," she wails at her parents. Would you be friends with someone who had more than you? Less than you? Clair asks. Yes, Vanessa says. Well, then it's those girls who have the problem, Clair says, and honey, you are rich: you have a family that loves you. Thanks, Mom, Vanessa says, and then adds, But when I grow up I'm just not going to have so much money. That way my kids won't have any problems.

She is ridiculous. I can see why my parents liked this show so much.

...

My mother, it turns out, does not remember her own Cosby Rule. Is her memory trying to disavow? I am surprised. Maybe, she said dubiously, when I asked her recently, years removed from that house, that

television, that ritual. She used a skeptical tone of voice she reserves for humoring me and which I am only able to align with Clair Huxtable in retrospect. Sure, my mother said, when she realized I had checked out all the library's available DVDs and brought them home for Thanksgiving. You brought what home? O.K., let's watch again. And so we did, my parents and I, our memories of 1984–92 stained by over sixty allegations of sexual assault against Bill Cosby, a man we had once thought of as the head of a family much like ours. Once again, I put my head on my mother's shoulder.

I told her: I felt dirty even taking the DVDs out of the library. She laughed a little, just to show that she got it, because it wasn't funny. We were watching Clair—I had perhaps almost entirely disappeared into watching Clair—when one of them said: *She defended him. Didn't she?* She had. I don't remember if it was my mother or my father, but I realized: they couldn't forget either.

You have to understand: my father too has a kind face. My father too is a doctor. My father too would say *How. Much.* when we asked him for things sometimes, Cliff-like. My father too has an elasticity of spirit and expression; he can be silly even as he is stern and loving, and when I first watched Cliff, I did not know which father preceded the other. Now I am horrified that I ever thought of these two men in the same way.

Still, I am impressed by the show's lasting power. It does not appear in reruns as often as it might were its star's legacy not crumbling. It's sad that a show that did such a terrific job of portraying the generational transfer of knowledge will be erased because many people will be too uncomfortable to show it to their children. I don't blame them. But look: the physical and emotional closeness I loved in my first viewing was enabled, I suspect, by the cast's balance of five women and two men. Can it be, after all this news, that Bill Cosby made a show about women and their power? Is it possible to see the show this way? So often, *Cosby* humor arises from Cliff and Theo playing fools to the older women's competent straight "men." The boys attempt to hide their hunger for things they shouldn't have: food, money, markers of status. Clair in particular is excellent at catching her husband, who is supposed to be

as good as her and clearly isn't. She is in control; her daughters are her avatars. Sondra, the oldest child, is an academic high achiever like her mother and goes to Princeton; Denise has her mother's creativity, vivacity, and beauty; Vanessa possesses Clair's keen sense of ambition and justice; Rudy wields a hefty dose of her mother's charm, comic timing, and skill as a performer (in performance and social situations). The women are frequently powerful, competent, smart, and stylish, while the men are more often than not gentle jesters with aspirations to the same kind of discipline.

Or is this feminist reading simply my desire to redeem the show in the wake of the allegations about its star? Bill Cosby was ostensibly the sun around which the other characters orbited, even though he had a real rival for attention in Phylicia Rashad. The family was modeled on Cosby's stand-up, which was modeled on his own family. Cosby made me his ardent viewer by showing a kind fatherly figure, one who deployed his authority and his wealth to help and protect his family—when in his real life he used those things to endanger and lie to people. Many of his accusers relate experiences that fall outside the statute of limitations for prosecution; there is one exception for which he recently stood trial. Horribly, it ended in a mistrial. A number of the stories from Cosby's accusers include moments when Cosby allegedly took advantage of young women by leveraging his status as a mentor or a successful man with money and power. Knowing this, it is hard to watch him lecture the young actors on the Cosby set about how to conduct themselves responsibly with money. Be in the real world, he tells them. They take his advice and grow up.

Their "father" is the one unable to do so. Now, in the wake of the mistrial, Cosby seeks to resume his role as a giver of life advice: he plans a national series of talks aimed at helping others to avoid sexual assault charges. That reedited talk in Theo's bedroom, gone even more haywire.

...

I, in turn, once the faithful viewer, seem to have outgrown my television. *The Cosby Show,* the family-friendly and yet still willfully weird creation of Dr. William H. Cosby Jr., Ed.D., was the number one show in

America for five straight years. Once upon a time, watching it made me feel comfortable, smart, and included. Of course, that's no longer true. And nothing I've watched since has quite matched it.

A few years ago, I stopped watching television almost entirely. I had two televisions, and they sat in my apartment, big and dark and blank. I gave one away when I moved. The second I abandoned in an alley. It was the television I'd inherited, a television I could afford. I let it go and left it for someone else to pick up. And then for about a year, I had no television. I didn't miss it. I did not replace it until yesterday, when someone I trusted, upon whose shoulder I've slept, gave me an old television, and I thought, well, maybe I'll try again.

Yours, Mine, and Ours
Outside and Inside the Box

Jenny Hendrix

1.

I've been thinking about what it means to share things. About the difference between knowing someone and knowing something about them, as in some shred of demographic fact, and about the things we use to knit ourselves together or wall ourselves apart. About what it means, for instance, to share an awareness of certain cultural referents that identify us as part of a certain interest group, or a certain generation, nationality, gender, race, or class.

Consider an online listicle titled, "50 Things Only '80s Kids Can Understand." From this, it would seem that we understand consumer products, mostly—cereals, sneakers, VCRs, or Betamaxes—and celebrities, like Madonna or Baby Jessica. But even more than these, it is assumed we understand TV. Available for a limited time—like Wild n' Mild Ranch Fritos or Clearly Canadian cherry—our knowledge of, say, *Super Sloppy Double Dare* marks us as having set foot at a given moment in the Heraclitean stream of ephemeral pop-cultural production.

I was an '80s kid. I've known the little blue men in the forest and their nozzle-headed competitors under the sea. I've known the brash and brassy rabbit, the silly rabbit with a taste for kids' breakfast cereal, and the fast but culturally insensitive mouse. I've known bears whose tummies cure the blues and little girls who turn the dead grass green. I've known robots that become other things and a warrior princess and her warrior . . . brother? lover? friend? I've known a sialoquent duck, two drunk and flatulent dads, and a set of identical pig-tailed twins. I've known them, but I've never felt they were quite mine. Neither are the things I remember about them now, memories that appear almost accidental, a product of having stumbled into the world at a certain time, of breathing the air around me.

The things I call my own are personal: the taste of an apple blossom in the spring, a sled veering into a blackberry patch, a string of bells around someone's ankle, or the toothed roughness of the cedar branch on which one has sat down to read. These are my own, and I understand them in a certain way. Others may make of them what they want to.

Still, I was an '80s kid, born, more precisely, in Seattle in 1982. The years of my early childhood simmered in a residual heat left over from more than a decade before. Most elements of our daily life represented a preference for individuality and the heterogeneous, for a rugged self-sufficiency: brown bread and rice over white, home birth and herbal medicine over the sterility of hospitals, homemade sweaters and Halloween costumes over their department store kin, community over isolation. These were the values we lived by—not hippies, exactly, but hippie-adjacent. My dad, in mustache, puffer vest, and lumberjack shirt, splitting wood, smoking his pipe. Mom with her long, center-parted hair and oversized glasses, weaving a basket as her chickens ran around in the yard.

Two siblings came along, and we moved to an island—a forested, rural place that incubated a vibrant and eccentric cultural analogue to the wacky bloom of diversity one associates with the Galapagos Islands or Hawaii. There were potlucks and midsummer bonfires. There wasn't a traffic light to be found. My siblings and I began our education at a

Waldorf school in the woods, a part of the system devised by Austrian scholar Rudolf Steiner, the anthroposophist. There, we were forbidden to eat candy, wear clothing with visible printing on it (I remember children being asked to turn their T-shirts inside out), and play recorded music. Parents were strongly discouraged from allowing young children to watch TV.

Steiner died in 1925, leaving no opinions on this last. His abundant writings do, however, address the over-reliance on visual aids (bad), along with a panoply of subjects ranging from farming to architecture and alternative medicine. His pedagogy, according to which I was taught up to the fifth grade, was designed to respond to the developmental and imaginative needs of the child as he understood them—emphasizing inner development and the unification of the intellectual and spiritual capacities, free thought, intuition, perception, and creativity. The brilliant imagination of a child who is, as Steiner wrote, "all sense-organ" is meant to grow into the rational, questioning mind of an adult. But to do so, it must, plantlike, be carefully and lovingly fed, watered, and protected from the harsher elements: "Of prime importance for the cultivation of the child's feeling-life," Steiner wrote, "is that the child develops its relationship to the world in a way such as that which develops when we incline towards fantasy."[1]

It was thought, by those who followed his philosophy, that television hampered the development of this form of imagination in the young, substituting the pre-interpreted mass fantastical—images that direct and delimit a child's thought—for those more unruly, individualized, and potentially unbounded fantasies that arise through internal effort. A child who's watched hours of cartoons might direct her play along the lines of the rules and norms she's learned from Bugs Bunny, the thinking went, instead of inventing her own. Or the slow-moving reality of nature might pale in comparison to the way a child has encountered it on a show, leaving him uninterested in developing a primary knowledge of the world in which he lives.

This line of thought, I recall, met with surprisingly little resistance. It was taken as a given, among the islanders, that television was a terrible thing, the community's attitude resoundingly Oompa-Loompan:

It rots the senses in the head!
It kills imagination dead!
It clogs and clutters up the mind!
It makes a child so dull and blind
He can no longer understand
A fantasy, a fairyland!
His brain becomes as soft as cheese!
His powers of thinking rust and freeze!
He *cannot* think—he only sees![2]

Not that no one watched it ever, but even those who did own a television generally kept it covered with a cloth. At the time, I interpreted this as an attempt to thwart its big brother-ish gaze (it can see us!), but from the perspective of distance, it seems a gesture motivated more by modesty than anything else, akin to closing the lid on the toilet (we can see it!).

In our world, "mass culture" represented a shared set of ideas and values that arrived from the outside rather than having been generated from within. It was therefore considered phony and cheap—inferior, if not downright villainous—and duly shut out. I realize how near this draws to sanctimony, toward that troubling emphasis on purity of which the far left is often accused, and which forms the through-line between eating organic and being antivaccination. That is part of it too. But, much as I longed, as any child does, to be exactly like everyone else— slurping my mason-jar lunch of homemade soup in the library to avoid its being seen—as much as I hated carob and the cardboard loops we bought in bulk for breakfast, I recognized, in the likes of Tony the Tiger's protestation of greatness, say, something vaguely obscene. I've always held this suspicion, this sense that some fragile, precious part of oneself must be protected from those who would discount it or replace it with their own bought-and-paid-for version of what a person is and how the world should be. And so better to look for answers on one's own, rather than taking what was given to you. To prospect for them in books, to gaze out of windows, and, very, very early on, to write. Mass media like TV was, of course, deemed the opposite of being conscious: it was a tool by which preexisting social values, many of them bad ones, were

spread. I delighted in television when I watched it, but the few moments of viewership that I truly remember involved my getting up and leaving the room. To unplug was, for us, a political act: "George Bush is a bad president," I wrote not long after I could. "George Bush: Boo."

2.

Reagan had declared his "War on Drugs" a month and a half before I was born. It was the beginning of drug hysteria, the crack epidemic, and "Just Say No." I took D.A.R.E. and won all of its weekly essay contests with passionate defenses of the uncorrupted mind. I nodded at the old "This Is Your Brain on Drugs" ad on TV, the somber every-dad and the egg cracked into the hot cast iron pan: "Any questions?" But in my world, it was TV itself that "rots your brain." Fried egg–like, the mind of the couch potato was known to be flaccid and gelatinous, rather than clean, clear, and contained. These were the days of Marie Winn's *The Plug-In Drug* (1977), Jerry Mander's *Four Arguments for the Elimination of Television* (1978), and countless alarming op-eds on the dangerous effects of the "boob tube" on developing minds. As critic and TV producer Richard Schickel wryly observed in a *New York Times* review of Mander's polemic, "The brightly glowing box in the corner of the living room is perceived by those who write sober books and Sunday newspaper articles about it as a sort of smoking chimney, spilling God knows what brain-damaging poisons."[3]

Yet even those who chuckled at the general sense of alarm tended to accept, at the time, that television presented certain drug-like dangers, that one could get hooked on its mediated version of experience. Everyone knew that it turned us into passive receivers of its message and was controlled by corporations that used it to sell us stuff we didn't need. But everyone watched it anyway. Driving around the island, we encountered bumper stickers exhorting us to "Kill Your Television." The violence of the demand felt telling: TV was so dangerous that one could not just get rid of one's set. It had to be murdered, eviscerated, smashed—its insidious flicker extinguished once and for all lest the slightest glimpse drag us back into a state of full-blown addiction.

3.

Still, it is a Sunday morning. Three children sit on a futon in front of a television screen. Not too close, of course, in the interest of their eyes. Two of them wear leggings, the other a bright sweater with buttons sewn all over the front. The girls are holding their dolls. The screen brings news of . . . what, exactly? Faces, voices, bodies rearranging themselves, brightly colored animals tumbling by in an endless footrace. The cat chases the mouse into the doghouse and, delightfully, is eaten up by the dog, his tail protruding, stole-like, from between the dog's teeth. A woodpecker laughs diabolically and flies away. There are the first inklings of death, when a boy's parents, and then he too, are turned into stars. Brought to you by the letter *P*.

Our TV, an old Panasonic that my mom has never bothered to replace, resided, for most of the years I can remember, in a sort of armoire. An unwieldy pair of rabbit ears perched on top, and turning on the set—that satisfying, high-pitched up-lilt—was usually followed by a period of whirring static, until one of us attempted a sort of slow-motion dance, experimentally prodding at the air with the rabbit ears around her head, extending one and then the other telescoping branch, draping them over the armoire's door and rotating the door forward and back standing on the arm of the couch, while the other kept an eye on the image and yelled, "A little more!" "Oh, no! Back!" or "STOP! Right there!" until we gave up and accepted the occasional streak of snow.

On Saturday or Sunday mornings, there were *Merrie Melodies, Tom and Jerry,* and the *Bugs and Daffy Show,* mostly, and then later shows like *DuckTales, Rescue Rangers, The Rocky and Bullwinkle Show,* and *Captain Planet.* During a certain period, we sat through the execrable *Mummies Alive!* each week, a show that featured a laughable rap-inflected theme song and a quartet of revivified Egyptians tasked with protecting a reincarnated boy-pharaoh called Rapses. It is possible that—like everyone who, as David Foster Wallace once wrote, secretly despises TV—we enjoyed this ironically, as a means of maintaining our distance. Or perhaps we just didn't want to turn off the TV between *Pokémon* and *Gundam Wing.* Perhaps we were "hooked."

I don't mean to give the impression that we watched TV a great deal—not, at least, until after we were older and our parents divorced and we found ourselves alone more often. Nor do I recall our consumption as having been curtailed, exactly—though it most probably was—other than by a general feeling that it was bad for us, that it was something to which we were vaguely opposed. Instead, watching TV was simply, and to an overwhelming degree, not what we did. I'm not even sure that it occurred to us to want to watch TV more often than we were allowed, instead of doing things like building our doll houses, making up plays, or exploring the stream across the road—those activities we rushed to after school.

And yet, somehow, my siblings and I still share the common vernacular of our generation. We understand just as the listicles say that we should. So we knew even back then how Urkel, annoying as he was, should be tolerated. So I knew I was supposed to heart J. T. T. without ever having seen an episode of *Home Improvement* or an issue of *TigerBeat*. So we still say, "Here you are, Nelson," in just the right cheery tone because of something that happened on *The Simpsons*. We all know the meaning of "Seinfeld jeans" and "Rainbow Brite boots" and running in slow motion on the beach. These are jokes, I suppose, and a form of nostalgia for something we never really knew. They are also a kind of code for interpreting the actual stuff of life, a shortcut to meaning. Which is precisely why the people I was raised by considered them so dangerous.

There is a way shared memories are useful, even if I have the sense of never having earned them, of never having had the experience behind the memory in the first place. Abstract cultural knowledge provides easy connections to those with whom you might have nothing else in common, a way of "being of one mind" without having to work through difference. Mass culture has the effect of destabilizing, if not entirely demolishing, distinctions of class: boss and worker chatting by the water cooler about last night's must-see TV. What could it mean, in our fractured and fragmented cultural age, that a group of people roughly equivalent to the population of New York City watched last season's finale of *Game of Thrones*? TV homogenizes us, but where inequality is

heterogeneity's darker flip side, that is not always a negative thing. Yet this is a diffuse sort of sociality, one having little to do with ourselves as persons—what Dwight Macdonald, in *Masscult and Midcult,* identified as uniting the masses. As a mass, he wrote, we "are not related to *each other* at all but only to some impersonal, abstract, crystalizing factor. In the case of crowds, this can be a football game, a bargain sale, a lynching; in the case of the masses, it can be a political party, a television program."[4]

Drawing a line from lynchings to *The Brady Bunch* may be a bit extreme, but Macdonald's point stands, I think. These are bonds based on sharing a reaction to something that is designed to produce that very shared reaction and so are dependent on it to hold. They don't address those things that distinguish us, individually, from one another—the understanding and acceptance of which create the kinds of strong connections found in families and small communities and between close friends. Even in my own family, I know that quoting TV shows or movies to one another becomes a kind of shortcut, a way to bypass those shadowy places in which lurk things like misunderstanding, obtuseness, and a fear of uncomfortable emotional truths, to arrive instead at a form of simulated unity that feels good enough for now. I recognize how much easier it is to discuss our latest binge-worthy Netflix fare than to take on the real stuff of hammering out relationships. And sometimes we need that, and I am glad it is there.

It's a strange fact of consciousness that its interactions with the world, despite and at the same time somehow *because* the world is shared, parcel us out into persons. The impressions we form divide us, usefully, erecting barriers around what we think of as self, cleaving me from all, creating difference. But there are times when something makes an appeal to that separate part of me—the part made separate by having rubbed up against all else that exists. A work of art, a landscape, or a friend leaps over the barriers, and something occurs that is beyond "understanding" in the BuzzFeed sense, beyond that kind of knowledge by proximity alone. I suppose that's what people mean by "communion." I'm trying to remember whether I've ever had that feeling with TV. Images from it, certainly, here and there, have moved me. I wonder,

now, whether there is something in the commodity nature of the thing, at least as it existed when I was young, that acted against this possibility. Because it spoke to us mainly as consumers, and not as people per se. Or because it gave us a way to see and think about the world, rather than challenging us to see and to think.

Joan Didion wrote, in "On the Morning After the Sixties," of her own so-called Silent Generation: "We were silent because the exhilaration of social action seemed to many of us just one more way of escaping the personal, of masking for a while that dread of meaninglessness which was man's fate."[5] One might, perhaps, substitute *television* for *social action* here for the generation that followed behind. For us, TV both soothes and underlines that meaninglessness, a pleasant enough way to pass the time as we wait around to die. I've never owned a TV, but I do watch shows online, often after work, bored and entertained at once, just like Adorno said the worker wished to be. Impatient, I check the slider on the bottom of the screen to see how much time remains. Then I watch another episode or two. And throughout, there is that guilt, the helpless suspicion of capitulation and failure, of having surrendered some part of one's better self. Throughout, the voice in the back of my mind is saying that it should always be harder than this, that life does mean something, many things, if only I'd get off the couch and go see. That, maybe, the meaning lies at least partially in the hard work it takes to try and figure it out on your own. *For goodness' sake,* the voice says, *do you really want to watch* Turn? *Can you really think of nothing better to do?*

Endnotes

1. Rudolf Steiner, "An Introduction to Waldorf Education," The Anthroposophic Press, 1985, http://wn.rsarchive.org/Books/GA024/IntWal_index.html.

2. Roald Dahl, *Charlie and the Chocolate Factory* (New York: Puffin Books, 2007): 139.

3. Richard Schickel, "Two Cheers for Television," *New York Times,* April 23, 1978, http://www.nytimes.com/1978/04/23/archives/two-cheers-for-television-tv.html.

4. Dwight Macdonald, *Masscult and Midcult: Essays Against the American Grain* (New York: New York Review of Books, 2011): 8.

5. Joan Didion, "On the Morning After the Sixties," *We Tell Ourselves Stories in Order to Live* (New York: Everyman's Library, 2006): 330.

The Hourglass

Ryan Van Meter

I was reading a magazine when I saw a face I've known almost as long as I've known my mother's: Deidre Hall's, in a little box on a page announcing her return to NBC's daytime soap opera *Days of Our Lives.* She had been arguably the star because her character, Dr. Marlena Evans, was the show's most iconic. This was the character known even by people who had never watched *Days of Our Lives;* they knew of her kidnappings and catfights, maybe that she'd been imprisoned a couple of times in a couple of different dungeons. They knew that Marlena had been possessed, most famously, by a demon and subsequently exorcised by a man she was in love with, a man who had once been her husband and would be again, but who also, at the time of her possession, happened to be a priest.

I hadn't watched the show regularly since the summer I graduated college and sat around looking for a job—some fifteen years before. That year, I arranged my daily visit to the campus computer lab around *Days of Our Lives,* and many afternoons, I taped the show and watched it again later with one of my friends who had an actual job. That August,

I drove to Chicago and slept on the couch of another friend, and I watched *Days* up until the day I started my own actual job. After that, I set a timer on my VCR and came home to my studio to sit and watch my tape, but at a certain point, I got behind, and then I forgot to set the tape, and eventually I stopped trying to watch it at all.

Like me, my mother watched *Days of Our Lives* in college. She arranged her class schedule, as best she could, around its broadcast. One semester, she watched *Days* in the lounge of the building where her class was held so that she could see the end of an episode and still arrive on time. She studied education, became a P.E. teacher, and after becoming a mother, only watched soap operas during summers or long breaks. And so, starting around the time when I turned five, if my mother was watching *Days of Our Lives,* I was too.

I hadn't realized until the moment with the magazine that Deidre Hall wasn't still on the show. According to the article, she had been cut three years earlier along with her co-star/love interest Drake Hogestyn, the guy who was the temporary priest. That year, she had been making $60,000 a month, but the show's ratings were low, sinking lower, and as part of a deal that extended renewal about a year ahead, the producers fired her so *Days* could survive with severe budget cuts. A show that had premiered in 1965 and aired nearly every weekday since had almost ended, just like that. I made that tongue-clicking noise of my grandmother's that always signaled disappointment, shook my head, and felt something I would later recognize as grief.

About a month later, my dog tore a ligament in one of her knees and required surgery. On her first day home, I had to keep her confined to a small area. I laid blankets on the living room rug and blockaded the doorways with laundry baskets so that she was trapped between the sofa and TV. But she was confused and a little high and wouldn't lie down to rest her leg. She kept pacing and limping and whining. So, fine, I sat on the floor to make her be still and turned on the TV. It was one o'clock, and the guide on the screen told me that *Days of Our Lives* was about to start.

I was sure I wouldn't recognize anybody, and even if I did, I was sure I wouldn't know what they were talking about because too much time had

passed. But I sat through a couple of commercials, and then—a hospital room, a beeping machine, a doctor shouting through a mask at scurrying nurses. His blood-smeared gloves pressed the abdominal cavity of a woman draped almost entirely in surgery green. "She's still bleeding," he shouted, and as the machines beeped more insistently and the nurses scurried more nervously, the camera panned slowly, so slowly, up to a face clamped by an oxygen mask, beautiful dark-red hair fanned across a pillow, and I said aloud, to the dog I guess, "What in the world happened to Maggie?"

...

So I started watching *Days of Our Lives* again. And as I watched, I found myself wanting to understand that sudden feeling of loss I'd experienced a month before, as well as how I could have grieved a show I hadn't even been watching.

Days streams online these days, so I didn't have to be home at one o'clock in the afternoon, but at first, I did sit down to watch it when it aired with full attention. And many of the faces I'd watched during childhood were still there—the very same ones. Maggie Horton and Victor Kiriakis—now somehow married! Bo and Hope Brady. Jennifer Horton. Sami Brady. E. J. DiMera, who was an unborn baby fifteen years earlier during that last summer I'd watched, was now somehow an extremely handsome twice-divorced British man. Salem was right there, as it always had been—intact, busy, and familiar.

But it had always been familiar. *Days* had a family of doctors and a family who owned a pub, and they all lived in a town called Salem near some water, and people were always walking down to the docks, where there would be a foghorn lowing. Yet Salem was somehow in the Midwest. As a kid, I stared at my United States of America map puzzle looking for the name of the city, knowing I'd find it in my state, Missouri, which had always felt important because it was right in the middle of everything. (The Salem of *Days* was not, and simply could not be, the Salem in Oregon that was so easily pointed to on the map because Oregon was not in the middle of everything, and who had ever heard of it anyway?)

In Salem, the great, big houses had pocket doors and marble fireplaces, and there were always tables with crystal vases, that my mother said were "decanters," full of brown liquid. There were also a lot of cops: Bo, his brother Roman, and their friend Abe Carver. Shane Donovan and Patch, a guy who actually wore an eye patch like a pirate, were spies, which seemed at the time to be just another kind of cop, all of them always standing with their backs against walls and their guns pointed skyward before dashing around corners, chasing guys in leather jackets. Bo's apartment was in an old warehouse, and its door was made of steel with a big handle instead of a dainty knob, and it slid side to side in a thrilling way.

There was a lounge singer who sang a song that was on the radio, and she performed in a nightclub owned by her husband, and there were teenagers, Melissa Horton and Frankie, who were my favorite characters, and sometimes I liked Eve Donovan, another teenager, though she was often mean. There was a hospital and a country music bar. One summer, a killer stalked and murdered the women of Salem—he was named "The Salem Strangler" by the cops chasing him around corners. He was shown only once in silhouette, and I turned to my mother and named the killer based on the shape of his haircut. She said no, we didn't know who it was yet, and we would have to wait to find out. But weeks later, the killer was captured, and it was the guy with the haircut. "You knew it all along," she said, and it was clear I had been born to watch this show.

With police officers and doctors and businessmen and the guy who ran the pub and the woman who sewed clothes for the woman who sang, *Days of Our Lives* had a "these are the people in your neighborhood" feeling. As a child, because of the dailyness of soap operas, I thought of it as different from other shows we watched. *Dukes of Hazzard, Dallas,* and *Falcon Crest,* which were only on Friday nights, felt to me like "shows." We popped popcorn and carried it into the family room in shiny bowls. We unfurled blankets across the carpet and lounged against mounds of pillows. The shows' locales were stranger, farther-flung—Georgia, Texas, California—and these people had houses you could see the outsides of. The credits had sweeping shots: cars kicking

up dust and leaping across creeks, black machines pumping in oil fields, our president's first wife in a limousine. The falcon at the end of the *Falcon Crest* credits was my favorite moment of the whole evening. Just as the music swelled, the bird turned to the camera with red shields over its eyes. "Why are those things on the bird's eyes?" My parents' answer: so it couldn't fly away—it stayed put only because it couldn't see where to go. It was the saddest thing I'd ever heard, but I couldn't wait to see it again the next Friday.

But because *Days of Our Lives* and the soap operas my grandmother watched—the CBS ones—were on five times a week and took place in towns that looked a lot like ours, and all of the people had jobs I'd actually heard of, I felt as though we were watching actual people. All of the other stuff on during the day—game shows, talk shows, the news— also depicted regular people in regular clothes. There were no sweeping shots. There were no outsides of houses. So it seemed as though on soap operas, we were watching people living their familiar lives while we lived ours—families, neighbors, cops, and doctors. I thought of it as a kind of reality television, long before I knew that such a thing would actually exist.

···

Shortly after I started watching *Days* again, I called my mother and asked if she remembered why she started watching soap operas. *Days of Our Lives* began airing during the fall of her freshman year of high school, but she didn't start watching it until college. Until then, she watched *As the World Turns* with my grandmother, but she couldn't say why. Neither of us knows when my grandmother started watching soap operas, though she once told me that she would always remember where she was when she heard that President Kennedy had been assassinated: she had been watching *As the World Turns*. So she was watching it by the early 1960s, if not before. I had been very impressed by my grandmother's memory of that memory but would find out that almost everyone of remembering age knows where they were when they heard this news. (My mother: the school library.) Later, I realized what was actually impressive was that the show she had been watching when she

learned of the assassination was a show she was still watching on the day, decades later, when we were talking about it.

During my childhood, for one week every summer, my brother and I stayed at my grandparents' house, and my brother was usually outside doing whatever my grandfather was doing, and I was usually inside doing whatever my grandmother was doing: chores, cooking, making things, and watching her stories. "It's time to watch my stories," she would say, and there was something special about the attention she gave to *The Bold and the Beautiful* and *As the World Turns* when they were on, even if she was still busy with other tasks while they aired. "My stories," she called them. They weren't for anyone else.

But because I said I was interested in them, as perhaps no one else had done before, or hadn't in a long time, she made sure I understood what was going on. As each new scene began, she would look up from whatever her hands were doing and explain who we liked and who we didn't, who was nice and who was "nice-looking." She said that what we had to do was get me caught up.

At the beginnings of our summers off, my mother also announced, "I've got to catch up." It always sounded so important. And so I understood, even as a child, that part of the point of watching a soap opera was that it was fleeting, almost as though it were a live performance. The stories were a thing we were chasing, and if we didn't catch them, something would be lost.

...

Being caught up is remembering what has come before, like with any serial TV show, but distinctly for soap opera, it is also remembering for the characters what they do not. Yes, there are flashbacks, and on *Days of Our Lives* they are lately presented in softer focus to make clear *this is a memory!* To really underscore the point, after the flashback returns us to the present scene, there is also a sound effect of a woman gasping. (The very function of memory, this suggests, is a shock.) For the most part, though, characters' histories are usually so flattened that only the most monumental events of life—relative to the drama of their everyday— seem to be remembered. This is necessary because a character might

have appeared in thousands of episodes, and the writers of soap couldn't possibly take into account all of the experiences that matter to any particular moment.

To the viewer who isn't caught up, a scene where a woman (Vivian) walks up to a married couple (Maggie and Victor) at a restaurant and the wife rolls her eyes and says something sarcastic registers only as two women who don't like each other very much. But the regular viewer who has kept up with the days of these lives knows that the woman once entombed the wife in a sarcophagus to prevent her from marrying the eventual husband. A character who has a realistic memory might more believably shriek in horror at merely the sight of the woman who once sealed her alive in a stone coffin. The pleasure of being caught up, then, is seeing the part of the story that isn't there.

On the phone that day, I told my mother I had a theory: I think you have to be taught how to watch soap operas. It seems that most soap opera fans start watching soaps because someone else in the house is watching—like a mother or a grandmother. "I remember watching you watch it," I said to her, "while I was watching the show." She thought she knew what I meant. Something about how we used to talk back to the TV. "You'd be watching two people talking," she said, "and sitting there yelling 'Just say it!' about some secret we knew that one of them didn't. But of course they never would." I told her I still did that. Because I do stand in my kitchen, and say, "Oh, brother," a lot to nobody when a character is being disingenuous, stupid, or hypocritical. I stand in my kitchen and say, "I hate Jennifer," a lot because it reminds me of watching soaps with my grandmother, who used to say aloud that she hated this one villain every single time she appeared on screen, but also because I really hate Jennifer.

I realized then that part of what I was watching when I was watching *Days* were the memories of all the other times I've watched *Days*. New characters often come to town, but mostly I wait through their scenes so I can watch the characters I love, which are almost always the characters I've been watching for decades. And most of the time, what I also love is the actor I love playing the character I love. *Days* has recently brought back the character of Eve Donovan, the teenager I

liked sometimes even though she was mean. She's not nice now either, but she's played by a new actress who is totally fine as Eve, but I don't really watch her scenes with the interest I would if it were a scene with Marlena or John or Maggie or Hope or, yes, even Jennifer. What I want are the same characters played by the same actors since I was five. I want to watch Marlena and Kristen fight over John the way they have since I was in college in 1996. I want to watch Stefano, Salem's evil mastermind, die in this explosion while remembering all the other explosions, as well as the drownings and gunshots and cave-ins and the time we were told that all of his blood had been drained from his body before it was then charred. Every day, with every episode, I want to continue pulling that long line of a character's history, and I want to watch it as it stretches alongside mine.

I realized I maybe didn't enjoy watching the show for the pleasures of the story as much as I enjoyed being caught up. I found myself able to skip weeks at a time or watch only the episodes on Fridays. (On soap operas, just as in life, the exciting stuff happens on Fridays.) Watching once a week was enough to stay caught up, and staying caught up, it turned out, was also enough. Maybe what I had been afraid of losing was that time I'd spent watching, by myself or with my mother and my grandmother, and what I had really wanted was for all of it to mean something.

···

I called my mother another day to ask if she remembered when she stopped watching *Days of Ours Lives*. "A long time ago" was all she knew, so I asked if she remembered why she had stopped watching. I wanted to know why she didn't miss it. How could she just stop watching without feeling any kind of absence? She lost interest, she said. She thought the show had gotten silly.

When she said this, I realized I watch *Days of Our Lives*, and always have, because it is silly. I want it to be unrealistic. To be contrived. I appreciate how—there is no other word—*bad* the stories can be. Not only outlandish—though this is when *Days* is at its best—with faked pregnancies and mind-control drugs and the sex tape played on the

big screen above the church altar at the wedding, but also the naked manipulations of the audience itself. The offspring who I remember being born only a decade earlier who are played by actors seemingly older than their parents. The character who is talking to herself and revealing—to herself—her biggest secret, only to be overhead by someone who somehow entered the house silently. The single day in Salem that stretches over twelve episodes. How characters are always running into each other—often into exactly the person they are avoiding—and *actually* running into each other, with purses spilled, lipsticks rolling. How, for no reason, characters wander down to the docks, and then, encounter trouble—which always happens at the docks, so stop going there! How, also for no reason, characters go to the hospital, hang out there, get into fights there. How no one has a birthday or a pet or a car. The characters—so many characters—I have watched die on screen who come back years later, alive, sometimes with a totally different face and voice.

Silly as these manipulations might be—and *silly* really is the right word—they are always in service of giving us what we want: the supercouple's reunion, the rerun of the showdown, the same old catfight, just in different gowns.

...

So, grief turns out to be a tricky sensation to feel about a soap opera. Because the moment a character heals after some loss, the moment there's a weary but wistful widow in her dressing room minutes before her next wedding, there's a knock at the door, and delivered in a wheelchair, by her nemesis, of course, is her former husband, the dead one, now alive. Characters leave Salem to tour Europe and figure things out after nearly dying in an explosion at a party. They go to boarding school or jail, move to Chicago to pursue a singing career, to New York to pursue a modeling career, to India to pursue a film career, to Japan for business, but they still can come back. No one is ever really gone forever on a soap opera.

Since 1965, the opening credits of *Days of Our Lives* have featured footage of an hourglass with sand pouring down, the bright blue sky

behind it suggesting noon, as there's barely a shadow. And as it has been since the show first aired, it's Macdonald Carey's voice in the credits, saying, "Like sands through the hourglass, so are the days of our lives." He was one of the original characters, appearing in the first episode as its patriarch Tom Horton, but he—the actor—died some twenty years ago from lung cancer. Yet he can still intone that epigram—ominous as it is. It must be trying to sound like an affirmation, but there are days when I hear it as a warning.

Alice, the matriarch, Tom Horton's wife, had also been on the show since its first episode, and she's usually brought up when Tom is, even though the actress died in 2010. Every Christmas, generally in the last episode that airs before actual Christmas Day on the earthly calendar, all surviving Hortons gather with many of the show's other characters to hang glass ornaments on an oversized tree, each ornament naming someone from present and past. Most years, at the end of this episode, there's a slow fade, and the last thing we see are Tom's and Alice's names in cursive glitter.

Where else, besides in a soap opera, do we get to see what could happen if someone we loved and lost were ever returned to us? That's what Salem is to me. And there's something exhausting about its seemingly bottomless capacity for drama—that no one, not even the most super super-couple is ever far from tragedy. That ease, no matter how well earned, can never last long. But there's something beautiful, too, in the way these characters survive anything: forced amnesia, stolen organs, exploding caves, poisoned doughnuts. It's how I can stand to watch these faces I've loved since childhood go through each day's new misery— because they will be O.K. Love is stronger than possession by the devil himself. In Salem, all it takes to survive anything and everything or be remembered forever is the fact that Salem is still there.

...

The last time I saw my grandmother was the hottest summer she could remember for her corner of Missouri. Five chemo treatments done of six, she was wearing her new wig even though she wasn't very sure about it. She was eighty-seven, and she'd just made my grandfather, my

mother, and me a big lunch, despite my mother telling her not to. As we were cleaning up the dishes, she came into her kitchen and looked at her clock. I was standing at the sink, watching myself watch her in the mirror that hung above it. "Oh, shoot," she said. "I forgot to turn on my story." She made the tongue-clicking noise. "It's Friday," she said, "and there's always a cliffhanger."

Always a cliffhanger. This was the problem with the possibility of *Days of Our Lives* coming to an end. It's just not meant to. The form doesn't really allow it. Because every scene in every episode of a soap opera builds toward a moment, suspended. By which I mean, scenes don't ever really end, and so neither can the stories. Conversations are always interrupted by meddlers, cell phones always vibrate right before someone explains something crucial. The doorbell rings, a fingertip is raised, and "Hold that thought" is uttered right before the Great Big Secret is nearly given away. Or if another character doesn't interrupt, then "I have something very important to tell you" is followed by a commercial, and when the scene returns, the thing that she had to tell him is definitely not what we thought—what we hoped—it would be. The very strict form of soap opera is about getting as close as possible to the revelation and then revealing something else that's unrelated or innocuous, or just not revealing anything at all. Because for a revelation to actually be *the* revelation would mean that the story had reached some kind of resolution. In almost all other kinds of stories, endings are how we know that something has changed. In life, it's usually not until we see the ending of something that we understand when it began or how long it lasted. But soap opera isn't about change, and it doesn't look like life. It's about the tease of "to be continued." It's narrative burlesque. So, how could a form that resists endings ever really come to an end?

Still, I know that one day it will have to end, and when it does, I know I will feel as though I've lost something that's been important for a long time, even if there have been periods when I have forgotten about it. It can be that way with people too, though I know that when *Days* ends I won't feel the same loss I feel when I lose someone important. But, more and more, I am understanding that grief isn't only the feeling of great loss. I think grief is also the feeling of measuring time. *Today would have*

been her birthday. This is the first Easter since she's been gone. I haven't dreamed about her for thirteen days. Of contending with the fact that you have more time than who or what you're mourning. I'm never more aware of the passage of time than I am after someone is gone.

So many of the titles of soap operas suggest this experience of measuring time. *Search for Tomorrow. The Edge of Night. The Brighter Day. One Life to Live. Days of Our Lives. As the World Turns.* The opening credits of *As the World Turns* featured the outer space view of our slowly spinning planet upon which one rotation creates a single day. For the early years of its run, *Another World* included in its opening credits its own ominous epigram, "We do not live in this world alone, but in a thousand other worlds." About the only regular visible endings on *Days of Our Lives* are in its closing credits, during which that same hourglass continues to pour sand, but the sky behind it now glows duskily. Today is over, this tells us, but only until tomorrow.

Very Special Episodes

Rumaan Alam

My childhood was very boring. This is the ideal for childhood, I understand, now that I'm a parent myself: *nothing happening* is all a father or mother could want. But despite my own shyness, I longed to break out of my cosseted, middle-class universe. I craved *action*. Yes, yes, I had imagination, that thing so vaunted when we talk about children. But that's more accident than accomplishment; the line between reality and fantasy is at its most porous when we are young.

I played at G.I. Joe, but my most ardent desire was not to forestall nuclear war but to live a normal life. Because I knew, quite young, that I was *not* normal. I defined this as "weird," and held that weirdness close and secret, a most magical form of thinking, a vague way of admitting to myself that I was gay, and acknowledging that being brown as well as bookish made me different.

Yes, books: thank goodness for those. They reaffirmed what I already suspected: that the world was a scary place. A favorite, when I was seven, was called *When Hitler Stole Pink Rabbit,* because I, too, had a treasured toy bunny and I liked to imagine Hitler on my tail. A favorite, when

I was eight, was *Harriet the Spy,* because I, like Harriet, had a sense that adults were not leveling with me about the nature of the world. But Harriet had interesting people to snoop on, and I only had books. And I couldn't find the truths I sought in my books. But I found what I wanted—the truth—at last, on television.

Television makes a very simple promise: give it attention and it will give you action. Yes, television will make you want a new car or dandruff shampoo, but it will offer you (gratis!) some of the other stuff lacking in your life: police detectives and pathos, blended families and bathos, car chases and comic relief, first kisses and the frisson of voyeurism, all of which were in short supply in the exurbs in which I grew up.

Via television, I could at last play Harriet. I could snoop on and attempt to ape the kids I saw on screen—straight, white, wiseacre but good-hearted kids. I could affirm my suspicion that I was *not normal* by confirming what normal looked like, and I could understand the rituals of American life that my immigrant parents were ill equipped to teach me.

In *Don't Tell the Grown-Ups,* the writer Alison Lurie makes the case that, the world over, children—"an unusual, partly savage tribe"— find their way to literature that "recommended—even celebrated— daydreaming, disobedience, answering back, running away from home, and concealing one's private thoughts and feelings from unsympathetic grown-ups." This is at odds with our notion of kids' literature as all talking bunnies and happy endings, but that's because we're grown-ups and we've forgotten.

Instructive moral tales for kids are full of goblins under the bridge, monsters in the closet. They're meant to scare readers straight, but it doesn't always work this way. Parents enjoy Maurice Sendak's *Pierre* because of its lessons on the danger of apathy. Kids (or me, anyway) simply enjoy seeing Pierre suffer death by lion, like an early Christian.

Lurie's hypothesis holds when you substitute television for books. Television for young children is about learning phonics and empathy, but I was thrilled by the masked villains on *Scooby-Doo,* the hints of marital discord on *The Flintstones.* On *Sesame Street,* Oscar lives in a

garbage can. As I said, when I was seven, I wanted Hitler to chase me across Europe.

Kids are given television that stresses the importance of toothbrushing and the pleasures of civility, and adults think we're so very clever, that we've folded instruction into entertainment the way some slip cauliflower puree into brownie batter. Kids are smart. A PSA once warned six-year-old me away from poisonous substances by encouraging me to look for Mr. Yuk. I used to search out his green countenance and consider that imbibing whatever bottle I found him on might lead, at last, to *action*. Mr. Yuk, meant to frighten, seemed as appealing to me as the Louis Vuitton logo does to some.

My parents thought of television as garbage, a necessary evil; I only have two kids (my parents had four!) and without the idiot box to babysit, I would not be able to shower as often as I am. But just because something is rubbish doesn't mean it doesn't matter. Television taught me a lot.

The television I watched as a kid satisfied my own dark tastes, the premises of my favorite shows—comedies, all—each distinctly unfunny. On *Silver Spoons,* a boy confronts the father he's never known, and learns to be a child as his father learns to be an adult. On *Punky Brewster,* a girl is left to defend herself in an uncaring world, and chances upon a genial protector. On *Diff'rent Strokes,* two brothers trade rags for riches, but this opportunity is theirs only upon the death of their mother. The otherwise unremarkable *Valerie* used failed contract negotiations to occasion the brutal death of its titular heroine and spend its final years looking at how family does or does not endure.

True, the death of a parent is narrative 101, the quickest way to conjure empathy for characters, and a shortcut to launching a hero on her quest. I didn't know that, staying up late to watch Arnold and Willis Jackson navigate Park Avenue privilege. I was a child, and like all children, I was a monster. I watched Valerie's sons cope in the aftermath of her fiery death and wished one of my own parents would perish in a fire. Sandy Duncan would come to stay and life would, at last, be *interesting.*

Despite the seriousness of these *situations,* these shows mostly spent their twenty-two minutes on *comedy:* adolescent acne, farcical

miscommunications, chaste romances. This was meant to be diversion, but I found it educational. I needed this instruction on the ways of life for my American cohort. My parents were neither illiterate nor ill informed, just not interested in the conventions of American childhood. We were left to sort that out on our own. Younger siblings always ape their elders; I looked to the girls of *The Facts of Life* as role models.

If I was personally disposed to find the educational in the entertainment, nothing entertained me more than when television turned explicitly didactic. The three little words most able to thrill my preadolescent self were *very special episode*. I remember these as appointment viewing, a break from the business of comedy to teach a lesson: about drugs, illiteracy, sex and its most tangible consequence, pregnancy. Viewer discretion was advised. That was a warning, but to me it was a promise. I knew that something good (bad) was coming.

Again, as Lurie points out, this is how stories for children often work. Beatrix Potter is, in your memory, responsible for genteel, English-y tales of apron-wearing rodents in country idylls. Yes, and no; "The unconventional message is concealed behind a screen of conventional morality, which might have fooled adults, but not their juniors and betters," Lurie writes. "When I asked a class of students which character in the book [*Peter Rabbit*] they would have preferred to be, they voted unanimously for Peter, recognizing the concealed moral of the story: that disobedience and exploration are more fun than good behavior, and not really all that dangerous, whatever Mother might say."

To get our children to be gallant, we have to show them Goofus. We're trusting they'll get the message, but kids are wily. *When Hitler Stole Pink Rabbit* gave me something to have nightmares about, and that's why I loved it. Very special episodes offered a similar thrill: the world at its worst, just as I suspected but could never prove.

I don't know why very special episodes—a diversion from regularly scheduled programming, the selling of Hamburger Helper and Dodge minivans, to tell their captive, affluent audience not to drink and drive and to always just say no—became a convention of the form. It was more than a strain; it was a pathology, at least from the 1980s through

the early 1990s, maybe the logical next step after the admonitory after-school specials of the 1970s and the propaganda films of health and driver's ed classes.

Very special episodes offered Old Testament clarity. I was moved near to (O.K., probably all the way to) tears when Sandy, Carol's boyfriend on *Growing Pains,* succumbed to his injuries after driving while under the influence. I identified so with Carol, a hopeless nerd (one, naturally, quite beautiful) who had at last found love. He was taken from her in the most brutal and unforeseen (unforeseeable to a twelve-year-old, anyway) fashion. I was still four years from possessing a driver's license, but I knew I would never drink and drive.

I was shocked by Scott Scanlon's preposterous accidental death on *Beverly Hills, 90210.* Scott, like me, was a nerd, but this did not afford him safe passage through this cruel world. He toyed with a gun to show off that he, like his peers at West Beverly, was *cool.* Naturally, the thing went off, his bid for coolness quite literally blowing up in his face. I was as affected by Scott's death as I was by those brief seconds in the show's opening titles in which Jason Priestley is shirtless.

Very special episodes were marked by a tonal shift: foreboding music, the sudden absence of the laugh track. In an episode of *Family Ties* that's surely the apogee of the very special, the producers did away with the *set:* the proceedings are presented as a one-man show in a black box theater. It's about Alex dealing with a dear friend's death. I found his ache for this lost friend heartbreaking.

Family Ties was a show with ambition, and the very special episode's ability to moralize made it the ideal vehicle for Gary David Goldberg's genial liberalism: we got to see Tom Hanks in the grips of alcoholism, Elyse's aunt in the early stages of Alzheimer's, and a racially motivated hate crime, when a black family moved into the neighborhood.

Thanks to Tom Hanks's persuasive portrayal of a man desperate to drink, I was terrified of vanilla extract, because, one night, Hanks's Uncle Ned downs a bottle of the stuff. Drinking was fertile territory for the finger-wagging sitcom. Kevin, the eldest son on *Mr. Belvedere,* had a memorable special episode in which he appeared drunk. Tony, the eldest on *Blossom,* was a recovering addict and eventually Six,

Blossom's boon companion, turned to the bottle for solace and made it seem hopelessly glamorous.

Of course, I was not like these kids on television. I didn't have a close friend whose theoretical suicide would move me profoundly. My father didn't have a gun I could show off at a party. I didn't have a driver's license, so I couldn't be killed on the road. Drinking and drugs were an abstract proposition, until television taught me that it was part of the American teen experience. Lurie's students saw the appeal behind misbehaving as Peter Rabbit does. And I dutifully sampled some Blue Nun, straight from the fridge, somewhere in this period. If not for Uncle Ned and *Blossom,* I would never have understood that alcohol offered the appeal of oblivion.

The very special episode allowed television writers to indulge in the outré, in service of a moral point. It was the heightened stakes that most appealed to me. *Diff'rent Strokes* already had a most special premise—the intersections of race and class in one telegenic household—but there were episodes that shook me so I remember them now without the aid of YouTube. In one, Arnold and Kimberly hitch a ride (hitching a ride in Manhattan? wouldn't they just end up accidentally hailing taxis?) and are taken captive. Their captor intends to rape Kimberly and ties up her brother. Good lad that he is, he escapes, and we all learn a valuable lesson about hitchhiking, one that's reverberating to this day: our fellow Americans are not to be trusted.

In the other, Arnold and his pal Dudley are given presents and attention by a kindly neighbor. He has dark designs, of course, and it's Dudley who's the object of this fellow's lust. Again, lesson learned: beware strangers bearing candy and gifts, because they're just molesters grooming you into compliance. I was horrified but also captivated. What was going on out in the world? When riding my bicycle around our cul-de-sac, I took the occasional passing car for a would-be predator and raced back toward the sanctuary of our garage.

These particular episodes were sexy, counter to their intention, because any discussion of sex at all was sexy. When Blossom and her brothers weighed having sexual relationships (not with one another, this was network television, not Nabokov), I was thrilled but unable to

imagine a scenario in which I might someday face a similar reckoning. Television had taught me to think of sex as a proposition in which you are always merely a passive victim, like Kimberly and Dudley. I was meant to fear strangers and I did, but so too did I long to submit. Much as I thought a house fire consuming a parent had a certain romance, so too did being spirited away, even if by a criminal.

The sex on television always seemed wholly theoretical because it was relentlessly heterosexual. Sex in this manner was something in which I had absolutely no interest, so if the moral of the story was don't have sex, I was happy to listen. It didn't occur to me until adulthood that my attachment to much of the television I watched (and I watched a lot) was erotic. I thought I was interested in how Valerie's sons were managing life without her, but maybe I was just interested in teenage Jason Bateman.

The sitcom as a form—ostensibly squeaky clean—relied heavily on the fact that the boys and girls in its universe were sex symbols. Yes, when you're talking about Brandon Walsh, you're talking about a grown man, but a lot of time the boys (it was only the boys I was interested in) were just that: boys, subject to adolescence's unpredictable and rapid transformations, in one season a back-talking kid, in the next, a heartthrob.

Certainly agents and producers and the others possessed of power understood something when they urged their seventeen-year-old stars to strip down and oil up for *Bop* magazine. Though I was a twelve-year-old with occasional impure thoughts, it wasn't just that I swooned over the pretty boys—I was *moved* by their troubles.

Despite being one myself, boys seemed a species apart; I could not guess at their interior lives, so put off was I by their *exterior* lives: baseball and burping, video games and crushes on girls. It was television, at its most maudlin and ridiculous, that taught me that boys are people too. On *Growing Pains,* Mike, the snarky slacker portrayed by noted lunatic Kirk Cameron, crossed paths with a street-smart orphan played by Leonardo DiCaprio. I was enraptured at discovering that Mike had a reservoir of feeling that found expression in his desire to care for this boy, and discovering Leonardo DiCaprio, who was still a couple years

shy of his transformation into Ganymede himself (youth and beauty, they are fleeting!). Their relationship was played as some mix of paternal and fraternal—indeed, it's likely DiCaprio was cast mostly as a more comely alternative to Mike's brother Ben, to whom adolescence was unkind—but to my mind it was *romance*.

One of my favorite shows of my youth (I was a child, I had horrible taste) was *Life Goes On*, an almost unclassifiable piece of television, a very special episode metastasized into an entire series. A précis, as far as I'm able to recall: Patti LuPone is married to some generic guy; there's an adult daughter, a son with Down syndrome, and a young striver called Becca, the put-upon daughter who suffered on the level of a von Trier heroine. She pined after a boy named Tyler who did not love her. In my memory he is deeply beautiful, but I've recently Googled him and am horrified by the results. Never mind. He too had a sibling with Down syndrome, so we understood that he was beautiful but also that he was noble.

Tyler died in a car accident, and I was crushed. Becca moved on—Woody Allen is right, the heart is a resilient little muscle—and fell in love with Jesse, played by Chad Lowe. Naturally, he had AIDS. I can't overstate how devastating a revelation this was to me. There was a profound correlation, in the culture and in my mind, between AIDS and homosexuality, and my fascination with the former indicates some nascent awareness that the latter applied to me. Jesse had AIDS but it wasn't Biblical retribution for gayness; it was just an accident of fate. It was all horribly unfair, and I felt like Becca: destined to lust after boys of unreal beauty who would be dispatched from the world in car wrecks, only to settle on boys of more accessible beauty who could never kiss me because of AIDS.

To the modern eye, the very special episode has the innocence and the ham fists of wartime propaganda. That particular period of the sitcom passed; by the time I reached my adolescence, television reflected a post–Cold War comfort with the world. *Full House* treated essentially every episode as "special," with a concluding maudlin, moral moment, heralded by a swell in the sound track. Those lessons seemed silly to me, but perhaps, at thirteen, I was just too smart for the medium.

Contemporary television is mostly irony and knowing winks, but the sincere, heartfelt very special episode formed me, not as a writer (though perhaps there too) but as a person. I credit those writers and producers for harnessing television's remarkable power to teach me how to live. I grew up fearful of drugs, of drinking, of sex, as was intended. I'm almost forty and I still believe that drinking a bottle of vanilla extract might get you drunk.

But just as literature taught me to love the things it seemed to condemn—the lesson of *Harriet the Spy* isn't *don't spy,* it's *be willing to lie*—television taught me to appreciate complexity. My childhood, utterly boring, utterly without incident, had car crashes and lurking predators, deaths by fire and brushes with addiction. At times I could barely catch my breath. And if I was alone—and I was, mostly, alone—I had beautiful boys in dishabille and smart brunettes I wanted to befriend. NBC used to close its public service announcements with the tagline *the more you know,* and thanks to television, I knew everything.

Supportive Acts

Justin Torres

All Rickie's lines are transcribed from various episodes of My So-Called
Life's *first and only season.*

Rickie Vasquez is waiting to give you some attention. "You should buy
yourself something," he suggests. "I mean, think, what do you really
need? I mean . . . you need new makeup. Makeup goes bad, you know, it
does. It spoils. You need new CDs because the ones you have suck, and
you could definitely use a leather jacket." Rickie Vasquez is ready to fix
your life; he's ready to help you spend the money he does not have.

Rickie Vasquez is black and blue. "I like your house," he says.

Rickie Vasquez has been crushing on J.C. since before you figured
out how to masturbate, how to dye your hair. "Don't you love how he
leans?" Rickie Vasquez asks, and then in a flash he is ready to explain
you to yourself.

"Obsession," he says. "It's an obsession. I completely understand this."

Rickie Vasquez has been weaponized. You think Rickie Vasquez
wants to wear all this armor? You think Rickie Vasquez don't want a

little goddamn peace and quiet? Rickie Vasquez is standing in front of the classroom and he is saying, *they have made me into a gun I don't even know how to shoot.*

He is saying, "Maybe some people have guns to like, protect themselves. Maybe some people who have guns are like, victims, too. And they're like forced to carry."

He is saying, "You don't know what goes on around here, O.K.?"

You don't know, you don't want to know, you won't know.

But Rickie Vasquez makes pressure just by breathing.

"Ah, what's the difference," says Rickie Vasquez, changing the subject. "So, what's this I hear about you and Jordan?"

You talk.

"That's what I heard." Rickie Vasquez wants you to get to the point.

You talk.

"You mean you didn't have sex?"

You talk, something about having infinite opportunities for touch, intimacy, attention, still ahead of you, waiting for you to squander. Something about the centrality of your experience, your narrative; that you are the standard by which value is measured, that there will be boys for you, love for you, space made for your desire. That you look around and see yourself reflected in myriad advertisements, plots, soaps, television characters, books. It's 1994, you dyed your hair Manic Panic, your little sister is a brat. Your parents are maybe a little too attentive; it would be stifling if they weren't also so compassionate, loveable, capable—and if some little faggot can't relate to that, they better learn how. Learn to find joy in me, you say, be master of the vicarious. Supportive.

Rickie Vasquez is wondering if all you ever have to offer him are crumbs.

"Well, did you like the way he kissed?"

You talk.

"Go to hell," says Rickie Vasquez. "You know you're boring, don't you? You know I could have handled that."

The things Rickie Vasquez handles, must handle—so very different from those he could handle, would love to handle.

For now, Rickie Vasquez is the arbiter of your petty squabbles.

"I know," he says, "but you see, I can see it from your side, but I also see it from her side, and from my own side."

You gently remind Rickie Vasquez that he does not get a side, not really.

"But, I don't really have a side," he agrees, and again he changes the subject.

Rickie Vasquez is giving up the fight for the girls' bathroom. "It has nothing to do with what anybody said, it's just, I always knew why I was coming in here, O.K., but if people are gonna take it wrong, and give it this whole meaning that I never meant it to have . . ."

And then somehow this gets you telling him about real suffering, noble suffering, about Gregor Samsa, but Rickie Vasquez has questions.

"What? Wait. So, if they're starving him or whatever, then why doesn't he just leave?" You want him to believe that there is only one world, one reality, one family, one town, one race that matters. Yours is the one experience. You want him to believe that puberty has transformed him, that in this world, which is the only world, in this family, which is the only family, he will always be a cockroach, monstrous.

Rickie Vasquez nods along, but he ain't buying it. "All the same," he says, "if I were him, I'd be out of there, so fast."

You ask Rickie Vasquez who does he think he is, talking about setting off on his own, some kind of Columbus? Rickie Vasquez has no time for discoverers, but wouldn't mind being discovered, like Lana Turner. You want him to understand that bad things happen to those who forget their place is in the group, he could wind up with no one, homeless.

"Or," Rickie Vasquez suggests, "Diana Ross."

And then suddenly Rickie Vasquez is turning his attention on me.

"She's such a sleaze," he says. "You are like such an improvement."

I can't hear you, Rickie Vasquez.

Rickie Vasquez knows my little faggy secret and he's ready to announce it to the world—but I ain't ready.

"You knew that. You *must* have known that. *I* knew that."

Rickie Vasquez is the first openly gay teenage character in a leading role in a television series. And he's played by a Puerto Rican. And he's almost exactly my age; I am a freshman, while Rickie is a sophomore.

Rickie, I ain't ready, I ain't ready, I am not. One day the lunch lady asks loudly, *You know who you remind me of, honey?* And she does not say the name Rickie Vasquez, because Rickie Vasquez is not a name that sticks with her—she says, *That little Spanish boy from that show with the redhead girl.* Everyone can hear, and someone says, *You mean RICKIE VASQUEZ?* And everyone laughs, and the lunch lady didn't mean any harm, but Rickie Vasquez is a name that sticks to me, for years.

Rickie Vasquez doesn't give a shit if I'm ready; he's tired of waiting.

I hate the show. I tell everyone I fucking hate the show and I don't watch it—don't talk to me about it, I don't watch, it's nothing like real life, I'm not a fag.

I watch every minute. I watch Rickie Vasquez. Hard.

Rickie Vasquez has a bandana tied around his head like a fortune teller. Rickie Vasquez reads my fate in his own palm. I ask Rickie Vasquez if it might not be possible that I could somehow harden into another kind of man, if the years ahead are to be as desolate, as lonely, as hollow as I suspect they will.

Rickie Vasquez spits blood into the snow.

I ask Rickie Vasquez if fulfillment might not be around the corner. I ask Rickie Vasquez if I can stay a little longer in this lie.

"In my refrigerator," Rickie Vasquez says, wiping the blood from his chin, "we've got this mayonnaise jar that nobody wants to, like, admit is empty."

I tell Rickie Vasquez that I wish he could be the star.

"I wish I could get away with bicycle shorts," Rickie Vasquez says.

I tell Rickie Vasquez the resemblance is killing me. He is ruining my life. I want him off the air. He just keeps getting gayer, and more tragic, and his pathos isn't even the point—he's only there to add depth to the trials of the white girl. Rickie Vasquez is still spitting blood into the

snow. I tell Rickie Vasquez that I never expected to see my reflection and it's too much, too soon; it hurts to look at him. I feel like I should love him, and it should be simple.

"But maybe it shouldn't be. So simple," Rickie Vasquez says. "I mean, not that I know what I'm talking about, or anything, since I've never, you know, experienced this, or what have you. But even if I did meet the perfect person, I just think that it should be like a miracle, like seeing a comet—or just feeling like you're seeing one. Seeing the other person's perfectness—or something. And if you do it before you're ready, how are you going to see all that?"

I see Rickie Vasquez preening. I see Rickie Vasquez beaten. Rickie Vasquez has nowhere to go.

Rickie Vasquez is slipping on the ice.

Rickie Vasquez has collapsed and oh Rickie Vasquez we love you get up.

How to Be Pretty on TV
The Idea of Beauty in
Anne of Green Gables

Elisa Gabbert

Anne of Green Gables—the Canadian miniseries based on Lucy Maud Montgomery's best-selling children's book from 1908—first aired in the United States in February of 1986. My mother recorded the full three-hour program on VHS tape, and in 1987, when the sequel, *Anne of Avonlea*, aired, we taped that too. I rewatched the series, all six hours of it, probably once a year until I left home for college. I know it so well that I can almost "watch" it by memory, replaying long scenes in my head while falling asleep—the way my husband, then a teenage aspiring actor, entertained himself in the hospital after spinal surgery by reciting Shakespeare monologues to himself, and later "listened" to Tom Waits albums while stuck in an MRI.

In case you haven't seen the show or read the books—if you're not a woman about my age or Canadian—here's the plot in brief: Anne Shirley is a scrawny, redheaded orphan who has been passed between unwelcoming orphanages and adoptive homes (where she tended to serve as a caretaker for the family's birth children) throughout her

childhood. Matthew and Marilla Cuthbert are aging siblings who decide to adopt a young boy to help them run their farm (the titular Green Gables) on Prince Edward Island. Through a misunderstanding, they end up with Anne instead. Marilla immediately wants to send her back, as they have "no use" for a girl, but Anne has already fallen in love with the place, and Matthew is immediately taken with her. They opt for a kind of trial run. The ill-bred, outspoken Anne gets into a series of near deal-breaking mishaps but eventually wins Marilla over and stays.

Very early in the series, we learn that Anne is obsessed with beauty. When Matthew first picks her up at the train station, she tells him that while she's ecstatic about her new circumstances, there's one reason she can never be "perfectly happy"—her hair color:

> Red. That's why I can't ever be perfectly happy. I know I'm skinny and a little freckled, and my eyes are green. I can imagine I have a beautiful rose-leaf complexion and lovely, starry violet eyes, but I cannot imagine my red hair away. It'll be my lifelong sorrow. I read of a girl in a novel once who was divinely beautiful. Have you ever imagined what it must be like to be divinely beautiful?

Anne's red hair is her bête noire, overshadowing any other potentially appealing features—at one point she admits she is vain about her nose, having once been complimented on it. (Susan Sontag, in "A Woman's Beauty," writes that "women are taught to see their bodies in *parts,* and to evaluate each part separately.") When she arrives at Green Gables and it becomes clear she is not what Marilla ordered, Anne assumes her hair has something to do with it:

> MARILLA: How is it that you happened to be brought and not a boy?
> ANNE: If I were very beautiful and had nut-brown hair, would you keep me?

Marilla, who is both plain and sensible, assures her beauty has nothing to do with it.

Later that night, Marilla more or less commands her to say a prayer before bed. Anne, being "next door to a perfect heathen," is unaccustomed to the practice:

ANNE: What am I to say?

MARILLA: Well, I think you're old enough now to think of your own prayer. You thank God for his blessings and then humbly ask him for the things you want.

ANNE: I'll do my best. Dear gracious, heavenly Father, I thank you for everything. As for the things I especially want, they're so numerous it would take a great deal of time to mention them all, so I'll just mention the two most important. Please, let me stay at Green Gables. And please, make me beautiful when I grow up. I remain yours respectfully, Anne Shirley, with an *e*. Did I do alright?

Her beauty obsession is as annoying to today's viewers as it is to Marilla; we cringe and roll our eyes right along with her. Of course, at the time, an ugly girl was seen as especially useless. Anne, as an orphan, simply wants to have value; she wants the world to want her.

Equally early in the show, it's made clear that Anne is intelligent—in the opening sequence, for example, we see her reciting Tennyson to herself as she walks through the woods—but we don't hear it in so many words. Instead we get euphemisms (or dysphemisms, as the case may be). Take the fourth scene, where a very mean Mrs. Hammond—Anne's last caretaker before she goes to live with the Cuthberts—is returning Anne to the orphanage. Anne, as always, is exceptionally well-spoken, if florid and somewhat inappropriate:

MRS. CADBURY: And what were your parents' names?

ANNE: Walter and Bertha Shirley. Aren't they lovely names? I'm proud they had such nice names. It would be a disgrace to have a father called, well, Hezekiah.

MRS. CADBURY: It doesn't matter what a person's name is, as long as they behave themselves.

ANNE: Well, I don't know. I read in a book once that a rose by any other name would smell as sweet, but I was never able to believe it. A rose just couldn't smell as sweet if it was a thistle or a skunk cabbage.

MRS. HAMMOND: I don't know where she picks up them fool ideas, but she's a bright little thing, ain't she? And she won't be no trouble to you, I can promise you that.

One, I have always hated the word *bright* for its condescension; only women and children are ever called bright. Two, Mrs. Hammond only praises Anne here because Mrs. Cadbury really doesn't have room to take her back; it's a backhanded way of apologizing for her jabbering. Three, you can see that her vanity extends to her name ("Print out *A-n-n* and it looks absolutely dreadful, but Anne with an *e* is quite distinguished"), and her concern with beauty to words and names in general, which should always be evocative more than functional—not "Barry's Pond," but "The Lake of Shining Waters."

Anne is praised by Marilla and her teacher, Miss Stacy, for her imagination, her ambition, her accomplishments—she is at the very top of her class, goes on to college, and becomes a teacher—but rarely her intelligence per se. It creates the impression that Anne is what was known in my childhood as an "overachiever," implying that a student is not especially intelligent, just a very hard worker. (To my mind, "underachiever" was more flattering, suggesting that the true potential of your intellect was not yet realized.)

This mischaracterization—because Anne clearly is smart—may be kinder than it seems, because girls at the time were not *supposed* to be smart; it was not seen as a positive feminine attribute. Intelligence (and the associated schooling) was a distraction from a girl's duties: obeying God and her elders, finding a husband, and taking care of the home. Too, especially in *Anne of Green Gables,* intelligence is bound up with the sin of talkativeness. Anne is repeatedly scolded for talking too much, for her overactive "tongue": "hold your tongue"; "bite your tongue"; "her tongue appears to be hinged in the middle"; "she has a tongue of her own"; and, when she recounts how she broke her ankle falling off a roof

on a dare, "it's certain that she didn't injure her tongue." By constantly sharing her thoughts and putting her own fantastical spin on events, Anne violates the Victorian rule that children should be "seen and not heard." (Though in her case, adults don't seem to want to see her either.)

The only character who uses the word *smart* to describe Anne is Gilbert Blythe, her love interest and academic rival. When they meet on Anne's first day of school, he tries to get her attention by teasing her and calling her "Carrots." Anne loses her temper and breaks a slate over his head. From that day on, Gilbert chases her affections, but Anne is stubborn and unforgiving. She hears about his "smart" remark through Diana Barry, her best friend or, in her words, "bosom friend" (note: Josie Pye is a pretty, vapid brat and Gilbert's would-be girlfriend):

DIANA: Anne! You've got more nerve than a fox in a hen house.
ANNE: I don't see any need in being civil to someone who chooses to associate with the likes of Josie Pye.
DIANA: You're just jealous.
ANNE: I am not. You take that back, Diana Barry!
DIANA: She's jealous of you. Gilbert told Charlie Sloan that you're the smartest girl in school, right in front of Josie.
ANNE: He did?
DIANA: He told Charlie that being smart was better than being good-looking.
ANNE: I might have known he meant to insult me.
DIANA: No, he didn't.
ANNE: It isn't better. I'd much rather be pretty than smart.

Anne, Diana, and Gilbert all understand that there's an opposition here, similar to the opposition of *seen* and *heard*—beauty and intelligence are pitted against each other, as though mutually exclusive. Anne feels cheated out of prettiness by virtue of getting smarts instead.

...

Beauty versus intelligence is a common trope in TV, books, and movies— I think immediately of Jane Austen and countless dumb sitcoms—so

Anne of Green Gables was not my only exposure to it, but it's one of the first I remember. And I identify with Anne. But this is complicated by the fact that I was introduced to her at such a young age. I was six at the time, which means that I was just beginning to form long-term memories. (I remember isolated moments from kindergarten and even preschool, but I don't remember the Challenger explosion, which took place in January of 1986, so my memory was clearly selective.) Memory and identity develop at about the same age. So which came first: Anne or my idea of myself?

From early childhood, I was singled out as smart—*gifted* was the word they used. I learned to read at age three, and my mother claims I shocked the women at day care by speaking in complete and articulate sentences. In first and second grade, my teachers created advanced curricula just for me. (I distinctly remember having to use the word *splice* in a sentence.) By fourth grade, such measures were unnecessary, because my public school had a defined gifted-and-talented program. I remained on the accelerated course through my teens, but by then I no longer stood out as a wunderkind. The classes were larger, but also, I was increasingly resistant to the stigma of overachieving—I got A's easily, and that was enough for me.

My mother nurtured, doted on, even harped on my education from preschool right up until I got my college acceptance letters. She was proud and praiseful of my straight A's and good behavior—I was always a teacher favorite. My very smart but "underachieving" older brother, on the other hand, was often in trouble for mediocre grades and not eating his vegetables. My looks, which were neither exciting nor embarrassing, were very rarely commented on. If I ever disparaged them, I'm sure my mother contradicted me. But she seemed to largely ignore the way I looked, withholding both compliments and criticism. Now, having spoken to many women about the complexes their mothers gave them by putting them on diets or comparing them to their prettier sisters, I see this as a kind of parenting miracle, almost as though she was performing a social experiment on me. It awes me, especially because she wasn't unselfconscious; I remember her fussing over her hair and her weight.

The result of this unwitting experiment, and what I gathered from Anne and characters like her, was that my identity hinged on intelligence. I began to think of myself as smart and therefore, by definition, not beautiful.

...

Beauty has its own weird system of rules on TV. I find it uncanny when one TV character describes another as highly attractive—because almost everyone on TV is attractive. It's like the characters have incredible aesthetic abilities, akin to a dog's sense of smell, enabling them to distinguish among tiny gradations in attractiveness beyond normal human perception. This may be less the case for *Anne of Green Gables;* film wasn't really as prone to looksism then, and many of the cast members are elderly—Matthew and Marilla Cuthbert were played by Richard Farnsworth and Colleen Dewhurst, both in their sixties at the time of filming—and/or meant to be simple, unassuming small-town characters.

Anne herself is played by Megan Follows, a Canadian actress who was cast after many rounds of auditioning. The original favorite for the role was Schuyler Grant, who was suggested by her aunt, Katharine Hepburn. The director loved her audition, but there was outrage at the thought of such an iconic Canadian role being played by an American. Follows was called back in twice and apparently didn't nail the audition until her irritation over missing a flight gave an edge to her reading. (Grant was eventually cast in the role of Diana, the BF.)

Until recently, I'd always assumed that the show had been shot over several years' time, because in the span of three hours, Anne ages from twelve to nearly seventeen. Of course as a kid I was more susceptible to the tricks of both TV and time inflation—when you're six years old, three hours accounts for a larger percentage of your life than it does when you're thirty-six. I know now that Follows was the same age during the whole shooting of the first series. The apparent aging is the effect of hair, makeup, costume, and acting. In an old interview I found, the actress explains how the scenes were shot out of order, so she would often have to play several different ages in one day:

At first it was difficult, because even feeling like a twelve-year-old, in the beginning, would take a bit. . . . The funny thing was, I would find that when my hair would go into the braids, and I'd put on the orphan dress, or whatever, and the shoes, all of a sudden I just felt younger and I'd walk differently. . . . And then as I got older and the corset came on . . . you have to hold yourself differently. . . . The whole shape of your body changes, and the hair would be different, and you're all of a sudden in boots that have got heels on them, so you have to walk a little more controlled. You're more aware of your movements, and you're more aware of the fact that you look like an adult.

Megan Follows was seventeen during filming. In this interview, she looks like a typical '80s teenager—her hair is more blondish than red (she wore wigs and dyed her hair for the role); she has black plastic sunglasses pushed up over her straight, side-swept bangs. The footage is grainy, washed out—with a camcorder time stamp running at the bottom of the frame—but she appears to be wearing a sweatshirt.

You notice it here, and in her audition tapes, which are also on YouTube, and of course in later parts of the show when Anne has aged and come into her own, that Follows is very pretty, even beautiful. I used to think it was a remarkable stroke of luck that they managed to cast a homely adolescent who would turn out to be beautiful, just like in the books. How foolish of me! Now I can see she has the same face and the same body from scene to scene. So much of beauty is a social construction—smarten up your clothes and do your hair the right way and everyone starts to agree that you are pretty. When the people on screen remark on Anne's improved looks, we the viewers see it too.

On TV the contrast between the younger, stragglier Anne and the older, more poised and attractive Anne is all smoke and mirrors. I wonder—I don't know, because I never read the books—how the transition feels on paper. Reading the book, I imagine you can imagine that the young, unwanted Anne really is rather ugly, even if skinniness and freckles are no longer stigmatized. I have known many people in my life who were unattractive at twelve and very attractive at seventeen.

I myself was freckled and bespectacled and nerdy at twelve and much more attractive at seventeen. But the film version does the imagining for you, creating a disparity out of nothing. It's confusing to my memories, an illusion that begets another illusion—perhaps I did not change as much from twelve to seventeen as I believed? I do not know which illusion is less true.

...

On occasion, after binge-watching a show, I have had the eerie but not unpleasant experience of feeling my self-image merge with the image of the lead actress for a time—I take on her expressions and gestures, her patterns of speech, and seem to *feel* her face from the inside. It's somewhat like getting off a trampoline and expecting the ground to give under your weight—or, for that matter, like astronauts who come back to Earth and drop their coffee cups and toothpaste tubes, forgetting that gravity exists.

This is character identification par excellence—a level of identification seemingly unique to TV, being visual, a kind of full-body afterimage, and requiring more than the typical two-hour run time of a movie to take effect. But it only seems to work on the first viewing. It didn't happen when I recently rewatched the whole of *Anne of Green Gables,* including the sequel. I wonder if it happened when I originally watched them at six and seven. I may have felt my self, such as it existed, commingle with Anne's. I may have taken on Anne's aspirations as my own, her perfectionism and yearning to be beautiful, so that eventually, like her, I could will a more attractive self into being. But I may not have recognized the experience as such. I always think a feeling isn't real unless you can describe it to yourself.

Creek Theses

For Noah Ballard **Justin Taylor**

Cold Open

Because the dream of the '90s is still on life support in Portland (seriously, check our real estate listings), yesterday I walked over to the independently owned brick-and-mortar music-and-video emporium near my house to buy a used copy of the *Dawson's Creek* season 6 box set for $6. They had a second copy going for $8.50, which I assume meant it was in slightly better condition, but I'd decided beforehand that $6 was my price point. In fact, I'd come to this store a few times before and almost bought this particular box set, each time thinking, *Am I really going to do this?* And each time the answer had been no. It's not no anymore.

Dawson's Creek premiered in January 1998, and if you want more establishing detail than that, I suggest you Google it. I was fifteen at the time, halfway through tenth grade, and so not only part of the show's prime demographic but the same age as its main characters. Granted, I lived in semi-suburban North Miami Beach, and they lived in small-town (would it be unreasonable to say semi-rural? it always felt that way

to me) coastal Massachusetts, though the show was filmed in North Carolina, which is sometimes more and sometimes less obvious when you're watching, but I don't think any of this matters, at least in the context I'm planning to discuss the show today.

I remember that right before *Dawson's Creek* premiered there was an article in the *Miami Herald* profiling its creator, Kevin Williamson, (we didn't say "showrunner" yet) and that the article made bold claims to the effect that this show would provide special insight into teenage life as it was really lived today. I remember taking this very seriously and finding the prospect both terrifying and exhilarating. If the intent of the article was to stoke my interest in the show, it worked wonders, though if we're talking about demographics, it must be said that most teenagers don't typically read the arts section of the city paper, and so probably it—the article—was pitched toward my parents' cohort, a fact lost on me at the time, not that things would have gone any differently if I'd known.

The show premiered. I watched it. And I was powerfully outraged at what I perceived to be its failure to live up to the high-realist standard promised in the article. We—that is, us teens—were not only misunderstood, but misrepresented! That wasn't us at all! And what if other people fell for the paper's false claim and thought it was? *WHAT THEN?*

I'm not sure if my credulity and subsequent indignation says more about the kind of kid I was or about the era itself, but it is obvious to me now, as I am sure it is to many of you, that the claim of exclusive insight into the avant-garde of adolescent life is never not being made, and that it is never not false. But why wouldn't that be obvious now? I'm a thirty-four-year-old man who spent a decade in New York City knocking around the media and publishing industries, who has had many friends who were or are publicists, agents, marketing people, SEO ninjas, taste-chasers, taste-makers, and so on. I've even had, when occasion called for it, publicists of my own. Moreover, aren't we *all* in the media industry now? My Twitter feed is open as I write this; is yours as you read it? What's my point here? Oh, yeah. My point is that I have always associated *Dawson's Creek* with a very specific and personal coming-of-age, not vis-à-vis puberty or high school, but vis-à-vis public relations. What I mean is that I only ever thought the claim of its being "realistic"

was "wrong" because I'd made the mistake of thinking that such a claim could or would or should be "right."

I think I watched a season and a half, maybe two, of *Dawson's Creek,* in a mode that nowadays is called "hate-watching" but at the time was called "there's nothing else on, anyway." Which, by the way, was often true.

What do I remember about what I saw?

I remember fierce and sustained lunchroom debate over who was hotter, Joey or Jen, and that I took a staunchly pro-Joey position.

I remember being annoyed (separately from the outrage described above) every time a plot hinged on a piece of information that one character possessed but would not share with the person who obviously needed and deserved it. Characters talked about their emotions for what felt like hours on end but then trailed off (or stormed off), rather than share some basic fact of where they had/hadn't been or who they were/weren't there with or what they did/didn't do there—some fact that the audience knew was inevitably going to be revealed, so the ostensible "suspense" being sustained (for a few more scenes or even episodes) via the delay ended up adding nothing by way of character or story development and, for that reason, failed to register as suspense. The filmmaker Andrew Matthews identifies this sort of serial withholding/delaying as an endemic flaw of episodic television—an epiphenomenon of the sheer number of hours it takes to fill a season—and has coined the delightfully piquant term "plotblocking" to describe it. As a teenager, I didn't know how to explain what made me so crazy about plotblocking, but twenty years, an MFA, and three books of fiction later, I can now say that I disliked the over-reliance on dramatic irony as a driver of plot and that *Dawson's Creek* might, therefore, be the first piece of narrative art I ever objected to on aesthetic grounds.

What else do I remember?

I remember tuning in special one night because I'd been informed (by who? via what means? *Spin* magazine? carrier pigeon?) that there'd be a new Phish song debuted in that night's episode, and I remember feeling that it was important to support the band as they made their quixotic pop-crossover bid.

I have three things to say about this memory:

1) If I had to tune in special, I must have no longer been regularly tuning in.
2) You can tell quite a bit about the direction I was headed in, given what got my attention and inspired the special tune-in.
3) How fucking weird were the '90s, when Phish could be the reasonable choice for a *Dawson's Creek* tie-in song of the week? The song, by the way, was "Birds of a Feather" off the album *The Story of the Ghost*.

Oh, and actually there's a fourth thing, which I almost kept to myself, but having just taken a strong anti-withholding stance a half page ago, I guess I'd better go ahead and throw down:

4) The initial premise of my "memory" of tuning in special, and therefore also the premise of item 1 on my list, was falsified by less than a minute of internet research, which I only bothered to conduct in order to fact-check item 3.

It turns out that "Birds of a Feather" appears in the very first act of the very first episode of season 2 of *Dawson's Creek,* which premiered on October 7, 1998. (*The Story of the Ghost* was released on October 27.) In light of what I already told you about having watched at least a season and a half or two of the show—which I know is true—it is therefore impossible that I had to tune in special to see this episode. Whatever "direction" I was headed in, I must have been, at that point, still a regular viewer.

Close Reading

The scene in which the Phish song appears is so Peak '90s it will blow your mind. The episode, and therefore the season, opens with Dawson and Pacey at a hair salon, getting side-by-side haircuts on the morning of the first day of the new school year. Pacey urges Dawson to "get past the whole romantic checkmate thing you've been in [with Joey] for god knows how many years," before going on to affirm his own desire to

remake himself into someone who can "score with high-quality chicks." This is one of the show's innumerable examples of beta-male toxic masculinity (another mainstay of '90s culture), but its ickiness is mitigated if we recall that a major plotline of season 1 of *Dawson's Creek* was Pacey's seduction of/by his high school English teacher, Ms. Jacobs, which is to say his statutory rape by her. Pacey is the product of an emotionally abusive home environment, so his affair with Ms. Jacobs should be understood as his first encounter with genuine encouragement from an authority figure, which seems to me as important a "first" as the virginity he loses to her. At a certain level, Pacey wants little more out of life than a scrap of stability and for someone to be nice to him. That he has managed to figure out, with no help from anyone, that these things might be attainable with an age-appropriate sexual partner, and that self-improvement is a necessary precursor to pursuing such a partnership, speaks volumes to Pacey's natural intelligence and basic decency, two essential character traits he never loses and occasionally—like a shoddy Tim Riggins prototype—deploys to heroic effect when someone he loves is in trouble.

Here's a thesis: all of *Dawson's Creek* makes infinitely more sense, and is significantly more enjoyable, if you stop thinking about it as a show "about" Dawson Leery and start thinking about it as a show about Pacey and Joey, and the grinding misery of growing up working-class in a snow-globe town where all your friends are well-to-do.

But let's get back to the hair salon: Dawson is characteristically *leery* of Pacey's big plans. (You see what I did there? You see what Kevin Williamson did there?) Dawson makes that little incredulous snort—half "huh," half "eh"—that seems to constitute fully 40 percent of James Van Der Beek's dialogue. (Did he improv this or was it written in the script? Is it like Homer Simpson's "d'oh!" which is always scripted as the cue "(Annoyed Grunt)" rather than as "d'oh!" even though it's been definitively "d'oh!" for twenty-seven years? Who knows!)

Pacey, undeterred by Dawson's *leeriness,* pulls his head away from the hairdresser's scissors.

Pacey: "Molly, I need a new look. Let's say we . . . frost my tips, or something."

Close-up on Dawson, eyebrows rising: "Frost your tips?"

Close-up on Pacey, cocking his head: "Yeah."

Pacey breaks out into a wide grin.

Phish's "Birds of a Feather" pops onto the sound track.

Cut to exterior tracking shot: Pacey, his tips frosted, emerges from behind some trees, moving at a decent clip, wearing baggier khakis than you thought were possible, mirrored aviators, and some kind of collared short-sleeved button-up that I can only describe as a white-guy guayabera forcibly crossbred with a bowling shirt in the horrible laboratories below Stussy headquarters. The shirt has vertical bars, is three different shades of blue. Phish is still playing on the sound track. Pacey comes upon a parked police car and—opens the driver's side door? Sure. His older brother, Doug, we recall, is a local cop. This must be Doug's patrol vehicle. Pacey steals it, and here is the moment—Phish is still playing—when Peak '90s collides quite literally with Peak White Privilege.

Pacey pulls into traffic to try and follow a classmate he sees walking (to offer her a ride, presumably), but because he's watching her ass and not the road, he cuts off a woman driving a fancy sports car, who is unable to avoid hitting him and is understandably terrified by the fact that she just hit a cop. This is Andie McPhee, who will turn out to be a new student at Capeside High and the first serious girlfriend Pacey will ever have. Their romance (and subsequent friendship) will wind up being one of the more touching and sophisticated story lines the show produces. But we don't know any of that yet. In the scene, Pacey pretends to be the cop she thinks he is (the aviators help, the shirt doesn't), and then I'm sure the truth gets revealed soon enough in some wacky way I don't remember and am not going to go back and look up.

Montage

[Sound track: Phish's cover of the Talking Heads' "Once in a Lifetime"]

Me at a Phish show in South Florida, dancing in a muddy field. Me in a cap and gown, graduating from high school. Me living in glorious college squalor with a bunch of people who look like they might be homeless, but who definitely aren't Phish heads. Me running from a cloud of

tear gas at the first Bush inauguration. Phish is still playing on the sound track. Me standing in the middle of Times Square with my arms out, spinning around in a circle while the camera pulls upward in a big crane shot. Me in a cap and gown again, holding a somehow-already-framed diploma that just says MFA. Me standing outside of McNally Jackson bookstore on Prince Street, the entire window display filled with copies of my first book of stories—and, beyond that, a standing-room-only crowd. (Hey, it's my montage. Phish is still playing.) Me and a girl sitting together on the rocks by the water at the end of Grand Street in Williamsburg, passing a flask. Billboard in Times Square announcing my second book; I look amazing in my vest, and when the camera pans down from the billboard, there's me wearing the vest in real life, once again holding my arms out and spinning in a circle. Me and the girl from the rocks carrying boxes that just say "OUR BOOKS" up a flight of stairs. Phish is still playing. Interior shot, close-up on a female hand adorned with an engagement ring, poised before the power button of a stereo.

Female voice, straining to be heard over the music: "Can I shut this off?"

Male voice: "Yeah, sure, I would have shut it off earlier but I forgot it was even on."

Hand presses button; camera cuts to black.

Reunion Special

Dawson's Creek came back into my life under ambivalent circumstances in early 2015. For a variety of reasons, none worth attempting to justify or even allude to here, I had decided that I should revisit the show as part of the research for a novel I was working on. It helped—though "helped" is surely not the word I want here—that my now-wife and I were obliged by circumstance to spend the first four months of that year on opposite sides of the country. With what felt like nothing but time on my hands, "revisit the show" quickly devolved into "start at the beginning and see if you can make it all the way through."

Like Andie teaching Pacey not to hate himself just because nobody in his family knows what love is, my now-wife had taught me early in

our relationship that just because you can physically stand to watch ten straight hours of television doesn't mean you should. I can count on one hand the times we've broken our self-imposed two-episode limit, and each instance was the result of enforced confinement due to natural disaster. We spent one New York heat wave with *Game of Thrones,* Hurricane Irene with *Battlestar Galactica,* and Hurricane Sandy with *Buffy the Vampire Slayer.* I can't think of any other examples, and if I could, I wouldn't tell you. My point is she's got sense and discipline, whereas I have limited quantities of the first and effectively none of the second. I am never not cognizant of how lucky I am to have met her and managed to keep her. But like I was saying, she was out of town.

I watched at night, in nominally reasonable three-episode blocks, which at fortyish minutes a piece was about the length of a movie. If I couldn't sleep, that number might tick up to four or five. And lazy hangover mornings . . . well, you get the picture. The show was streaming on Netflix. All you had to do was nothing, and it would just go and go and go.

The Epistemological Function of Opening Credits, with Notes Toward an Epistemology of the *Creek* Itself

Due to a licensing rights issue, the streaming episodes had to replace some of the songs they'd used in the original broadcast (not Phish's though!), including Paula Cole's iconic theme song, "I Don't Want to Wait." Instead of that song, the opening credits are scored by Jann Arden's "Run Like Mad," a song (and an artist) I had never heard before I started streaming *Dawson's Creek* on Netflix.

Now brace yourself for heresy.

Not only is "Run Like Mad" a better song than "I Don't Want to Wait," it offers a far better entrée to the world of *Dawson's Creek.*

A theme song has to do a few different things all at once. First, it should be catchy. You should be able to hear it from the next room and know what's on TV. (In the old days, this often meant you also now knew what time it was.) More than that—and don't laugh, this is less obvious than it sounds and needs to be emphasized—a good theme song

functions as an overture, introducing the key themes of the show to new viewers and providing regular viewers with a transitional space through which to enter the diegetic frame in which the show occurs.

The theme song—and the credit sequence it accompanies—stimulates emotional enthusiasm and a suspension of disbelief while simultaneously mapping out the virtual reality of the show-world. In the show *Full House,* for example, the opening line of the jingle-like theme asks, "Whatever happened to predictability?" and is followed by each cast member striking some kind of signature pose. (Most TV shows throughout the history of the medium have adopted some version of the "signature pose" model.) *Game of Thrones* has an instrumental theme song and a literal map of the fictional world in which the show is set. The camera zooms across said map, pausing on the locations of particular relevance to the given episode or season. As the show progresses—and new regions become sites of conflict—the map itself expands. This is what I mean when I say that opening credits have an epistemological function.

The *Dawson's Creek* credits were reshot a few times over the years, but the basic elements always stayed the same:

1) Because Dawson is an aspiring filmmaker, the credits have the feel of home movies, presumably footage he shot himself, a visual decision that pays a double dividend by introducing the show's pervasive—sometimes smothering—air of nostalgia. It's as though *Dawson's Creek* were a more emo *The Wonder Years,* deprived of both its narrator and its formal relation of retrospection to its own content, but given to insisting nonetheless on the maintenance of said relation, if not as a fact then as a mood.

2) Footage of parental figures is glancingly brief (and later, I think, elided entirely).

3) The mostly outdoorsy settings, shot in broad daylight, prominently feature bodies of water: the dock in Dawson's backyard that sits on the creek, a beach, a pier, a swimming pool.

4) You see a lot more shots of the group of friends together than you see of the individual actors, and the arrangement of

bodies in these group portraits can tell you something about the relationship arcs of the given season, but the overall feel of the shots is always platonic and clearly prioritizes the group-as-group over the individual relationships within it. Despite having only Dawson's name in the title, the show wants to be understood as an ensemble effort, and insists over and over that everyone in its primary cast is entitled to story arcs of roughly equivalent import, and its actors to roughly equal screen time.

I'll say this for "I Don't Want to Wait": it works on a tonal level because it is overwrought to the verge of whininess, and a little stupid despite lyrics designed to convey maturity by dint of an ability to articulate desire. The most naive thing about it is how frank it thinks it is being, and in all these ways, it is an exact match for the show whose icon it became. "I don't want to wait for our lives to be over" sounds (to a certain kind of teenager) like a battle cry, but it's basically meaningless. Who *would* want to wait for their lives to be over? What would that sort of waiting even be? We are rallied to opposition, but against what? Moreover, *Dawson's Creek* is a show about deferral and refusal. It is this in its entirety, at every level, in every plot arc—to the very fiber of its being. It is positively Foucauldian in its approach to producing power relations and in the premium it places on self-regulation, never more than when it comes to sex. Pacey loses his virginity straight out of the gate in season 1 to Ms. Jacobs at around the same time that Dawson's mother is caught cheating on Dawson's father by Joey—who is in love with Dawson, who is in love with Jen. It's like *Melrose Place*! But instead of getting steamier and more convoluted, the show backs off from every single erotic gauntlet it has thrown and spends the whole rest of season 1—indeed, the next several seasons—trying to shove the sex-genie back into the bottle. The show does not always achieve this goal—people do have sex sometimes, and not all of them are punished for it by the god of retributive plotlines—but *Dawson's Creek* never loses sight of sexual repression/refusal/denial as some kind of bizarre attitudinal-behavioral ideal.

Maybe this is how New England is different from Miami, after all. Is this a Puritan thing?

Jack figures out he's gay and gradually comes to terms with that, but he also refuses for a long time to explore gay culture (what there is of it in Capeside), less because he's scared to than because he's a WASPy jock who, in all honesty, finds gay culture to be, well, a little gay.

Jen is introduced as having been a *slutty middle schooler* trying, at fifteen (!!!), to overcome her shameful past and start over. Like Pacey, the best way to understand Jen is as the product of child abuse, in this case upper-class neglect rather than working-class brutality, but what the two cases have in common is that no perpetrator is ever punished, which makes it much harder for both of them to understand the degree to which they are, in fact, victims of crimes. Again like Pacey, Jen has been shattered so completely at such a young age that she must spend the bulk of the show gathering up the fragments of her selfhood and attempting to glue them back together into a semi-coherent shape. If you think about her this way, everything her character does makes a hell of a lot more sense, and the contrast between her arc and Pacey's makes for a longitudinal study of society's crushing double-standard for adolescent sexual agency, which of course runs precisely along gender lines. To put it simply: for every time the show encourages Pacey toward someone who can please or heal or help him, for every time Jack is given opportunity to explore his sexuality and its attendant culture (which he can almost always choose to accept or not), Jen is forced to recall that she carries with her at all times—*in* and *as* her body—the capacity for irrevocable harm to herself and those around her.

Joey and Pacey spend the entire summer between seasons 3 and 4 alone together sailing on a boat named *True Love* that Pacey built from scratch—but they do not have sex. What are we to understand occurred on that boat? Did they take turns furtively masturbating in the cabin while the other stayed on the deck? Did they just have oral and/or anal sex constantly but hold off on crossing that last boundary due to some religious stricture that the writers had put in the original character descriptions but forgot to ever introduce into the show?

IS IT THE PURITANS AGAIN?

I think I'm starting to remember what it was about this show that made my teenage self's head explode. Now I will decline to pursue that line of inquiry any further except to say that, as stupid a conceit as it is, there winds up being a narrative payoff in not letting Joey and Pacey consummate their relationship in the interstitial space between the seasons. First, it allows Joey to lie to Dawson about having slept with Pacey, which she does for no good reason other than to freak Dawson out. Second, the conditions under which actual consummation might occur become the subject of protracted negotiation between them throughout season 4.

(Sidebar: My single favorite thing about the Joey Potter character, consistent throughout the show but never directly addressed as the pattern behavior it is: Joey is a liar. Whenever she feels defensive, confused, outmatched, or upset, her first instinct is to tell a wild lie. It's the one exception to her otherwise inescapable role as the goodiest two-shoes in the crew.)

Pacey and Joey talk constantly about whether and when and if they'll do it, and what the consequences of such an action might be. This is what I meant when I said the show's attitude is Foucauldian: sexuality does not produce sex, it produces discourse, one secondary effect of which may, at some point, be sex, but if so, the purpose of that sex will be to generate more discourse. Considered in this way, we might understand sex on *Dawson's Creek* not as an affirmative gesture in itself but rather as the failure or exhaustion of discourse. People fuck when they run out of ways to talk around or about fucking.

Whether the issue in question is sex, drugs, booze, prom, or college—and *Dawson's Creek* might have been the last major TV show to pointedly frame its issue-driven episodes as "issue-driven"—all the central characters are deeply cautious, self-aware, prone to both hesitation before the fact and after. As I mentioned earlier, Dawson bears the last name Leery. He is the only character on the show whose name is his fate. Even in those moments when everyone else has managed to take some kind of leap or step or stumble forward, you can count on him to react with a judgmental anger that wounds everyone close to him. He is the supreme nostalgist, never missing a chance to reminisce about the good

old days, simpler times, or the way things used to be. Dawson is the teen who stands athwart puberty yelling, "Stop!"

All of which is to say that these people *do* want to wait. They absolutely *do not* want to know right now, will it be?

Now here's Jann Arden in "Run Like Mad," the alternate theme song (the one I've now heard just over a hundred times):

> My heart is in my hands
> My head is in the clouds
> My feet have left the ground
> My life is turning around and round
>
> Every voice inside my head
> Is telling me to run like mad
>
> [. . .]
>
> Every heartbeat, every kiss just
> Makes me wonder what all this is

Here is the whole world of *Dawson's Creek* laid bare. Rampant use of the first person possessive pronoun is put to the service of intense but largely symbolic attention to the body, which leads to recursive movement, that is, spinning in place, specifically, a place where powerful ambiguities are forced onto occurrences—heartbeats, kisses—that are intrinsically devoid of ambiguity, tending instead to mean exactly what they seem to mean (we are alive, we are kissing), which, indeed, is the real problem with them: not a lack but a surfeit of clarity, none of which would be an issue if you were only able to heed the call of those inner voices telling you to run, which you can't, and—let's be honest, Jo— wouldn't even if you could.

DVD Extras

I didn't finish watching *Dawson's Creek* before I left New York. I made it to close to the end of season 4, or thereabouts, but then it went off Netflix

streaming. In Portland, I bought the season 5 box set but couldn't be bothered to watch it. I got married. I had a new town to explore. We adopted a cat. I came to terms with the fact that what I was doing wasn't really "novel research," at least not in the way I had initially figured it was. I re-foreswore binging.

But I have the completist urge, and every once in a while would play hooky from whatever I was supposed to be doing and watch an episode or two. I eventually made it through season 5, the first post–high school season. They exile Dawson to film school in L.A. while everyone else relocates to Boston but are all doing different things.

Jen discovers a talent for deejaying at the college radio station and gets involved with a cute dude from a band who turns out to be two-timing her with another girl, but then instead of being that girl's enemy, she remembers feminism exists, and she and the other girl become friends and start messing with the dude's head, which teaches him a valuable lesson about how to treat women, and it turns out he was only being a cad because he'd never been popular in high school and in fact was attempting his own version of becoming a new person—which, it would seem, succeeded beyond his wildest expectations.

Pacey is living on a boat again for some reason and has discovered he has a knack for cooking. He gets into restaurant work, starts learning how to be a high-end chef. Of course, the restaurant itself is a hotbed of melodrama, but I loved the depiction of Pacey—a guy who always hated school—finding a job he cares about and is good at, rather than being shoehorned into college along with the rest of the honor society dorks. Restaurant work shows him that there are more options in the world than following Joey to the Ivy League or becoming his own asshole father. I heard he becomes a hedge fund manager in season 6, which seems insane to me, but like I said, I haven't watched it yet.

Dawson's film school–related angst is pretty boring, but as ever with television drama, you've got to weigh what you're being asked to slog through against what's being set up. Dawson finally admits he hates L.A. and that he wants to transfer to school in Boston—Jen's school? Joey's? Whatever. He comes home to talk to his parents about it and has a huge fight with his father, who accuses him—not unreasonably—of

giving up on his own self-professed lifelong dreams because he'd rather do the safe thing than the scary one. The fight is still unresolved when, in the same episode, Dawson's father is randomly killed in a car accident, and the whole rest of Dawson's story line that season whiplashes into an exploration of grief and mourning.

And Joey. Where do I start with Joey? Season 5 is Joey's season. She gets one episode—"Downtown Crossing"—all to herself, and so Katie Holmes becomes the only member of the main cast to appear in all 128 episodes. (I think by this point everyone else was taking breaks to make movies.) She also gets the last shot of the season finale, which, when they filmed it, they thought might be the series finale, which maybe it should have been. She's alone at an airport ticket counter, buying a solo flight to Paris and grinning like a kid on Christmas morning, knowing she's about to be free—for a while, anyway—from the boys she grew up with and all the claims they've made on her and the little town where it all went down. Good for Joey!

But before that, during the season itself, she gets the two best guest stars the show ever had: Busy Philipps (fresh off the cancelation of *Freaks and Geeks*) as her wacky sexpot dorm roommate, Audrey (later Pacey's girlfriend, but still); and Ken Marino—then best known for the legendary sketch show *The State*—in the only noncomic role I have ever seen him in (though he's still pretty funny) as a creative-writing professor who all the students think is super hot, and who is so taken with Joey's promise that he lets her into his upper-division writing workshop as a freshman. At one point he makes her write about her relationship with Dawson in a blue book—a blue book!—while he sits there and watches her work, never mind that it's a fiction class, or that they're not in class at the time, or that that's not how writing works.

The professor also invites Joey to join this research group he runs where he and a bunch of grad students (if indeed that's what they are) are trying to solve a mystery relating to some third-rate knockoff of Emily Dickinson's "Master Letters" in the papers of some writer whose archives the university for some reason possesses. These details don't matter. It's not worth the ninety seconds of Googling it would take me to explain it. There's only one important thing about it, and this essay

won't end until I share it, and I can't figure out an organic way to work it in, and so I leave you—non sequitur—with my favorite thing about season 5, and perhaps of all of *Dawson's Creek*.

I leave you with an image, a fuzzy screenshot I took with my phone while watching TV at home in the middle of the day while my wife was out earning us a living. It's such a Peak '90s moment it couldn't exist until 2001, and I think it explains why we are drawn to keep watching things even when we don't really like them, and I think it makes a strong argument that such behavior, however ridiculous, also has legitimate—if limited—rewards to offer. Certainly this image explains, better than this whole essay has done, why I bought that last box set yesterday, and why I know I will eventually finish watching this dumb show. Without further ado I give you,

Ken Marino mansplaining Kafka to Katie Holmes:

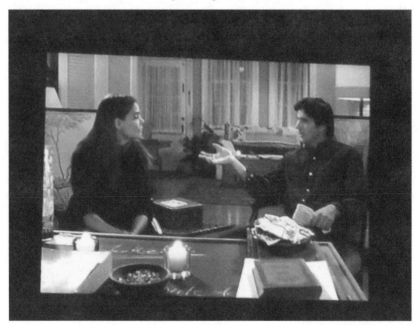

An Explanation of Music

T Clutch Fleischmann

The first time I saw sex was in *Emmanuelle in Space,* which aired on Cinemax late at night in the mid-nineties. It's a soft-core porn series where aliens come to observe Earth. The aliens' leader, Haffron, meets a magnificent slut, Emmanuelle, who is described by the opening voice-over as "one of the most sensual and beautiful of all Earthlings." Haffron and his extraterrestrial friends learn about sex from her, finding it both exciting and bewildering, as they don't have sex on their planet. In fact, we learn, humans are the only species in the known universe who have sex. For the remainder of the series, Haffron and Emmanuelle fuck all over the world, occasionally shape-shifting, and the other aliens put on virtual-reality devices to experience the sex along with them.

I watched *Emmanuelle in Space* over the summer between seventh and eighth grade, usually with my friend Samuel. This was shortly after premium channels started showing up on our TV, a mistake on the part of a cable installer, I think. Previously, my viewing world had been limited to five or six basic channels, their stringent morals giving way, at most, to the mild raunchiness of *Roseanne* or the scandal of

20/20. "Emmanuelle, queen of the galaxy" is how the title song starts, and she was.

The characters have the kind of soft-core sex where the camera cuts away every few seconds, where penetration is always suggested and elided. Samuel and I likewise looked at *Emmanuelle* and looked away, changed channels and changed back, always trying to catch a moment of the porn but not quite courageous enough to commit to what that meant. In most episodes, the cutaways are cuts to the landscapes of the earth or cuts to the aliens, hooked up to virtual headsets and caressing the air. The closest I had come to seeing a visual depiction of sex before this was on a condom box I found on a playground, the instructions inside of which showed a hand gliding along an erect shaft. *Emmanuelle* couldn't show this image, which would have been too explicit for the standards of Cinemax. Instead, viewers received the landscapes of the earth. That is, Samuel and I received everywhere that we were not.

It matters that I watched this with Samuel because the summer between seventh and eighth grade was the summer I had occasional sex with him. It was my first time and his. He lived in town, as did I. The town was very small, fifteen hundred people or so, but there was an old abandoned hotel at its center, and he would knock on my window at night and we would go there. When high school started, we stopped fooling around and didn't talk in any real way until the night someone lit fire to the hotel our senior year. That evening, he knocked on my window again, woke me, and together we watched it burn to the ground.

I watched several episodes of *Emmanuelle* with Samuel. No TV Guide channel to schedule us yet, the bodies of the aliens entered our home in a way that seemed equally random and destined. They were forbidden bodies, illegal bandwidth, like a mistake of existence. We saw, I know, the first episode, and the scene in which Emmanuelle tries to explain what music is to Haffron, why music does what it does. Music is one of many things unique to our planet, and, like culinary pleasure and war, the aliens assume these ceaseless obsessions are a consequence of our peculiar and pleasure-based way of reproducing. I know now that music can hold its power without sex, but I did not quite know that then. Then was a time when I often felt I didn't know.

It is difficult to recall what that total, exhaustive feeling of not know-ing felt like now that I know some things about sex. Here in summer, slightly stoned in the afternoon and with my partner sleeping naked beside me, his butt and tits a pleasurable distraction, I can convince myself I have learned something over the past twenty years of fucking however many hundreds of people I have fucked, of all different genders and bodies and ages and interests. I know, for instance, how to let my tongue massage the muscles of an anus before it opens itself further to me, how to tie hands behind a back with pressure that is both comfort-able and firm, but I still know nothing of why sex, or music, or sunlight holds its particular pleasure. At its best, in fact, sex is no more than a movement that draws me closer to the intimacy of unknowing, and at my most ecstatic, I give myself over to a desire that is unformed, more impulse than intention. My hand was drawn to Samuel's cock that first time as by thoughtlessness, and I had no ability to wonder at what would come next, or why—I had just that instinct to touch, and the sense that another instinct would rise when it was satisfied, and again.

As far as the aliens are concerned, Emmanuelle holds all of this knowledge. "Fragility is what makes people interesting," she tells them, and they nod. It is the aliens' curiosity she admires, and it is coura-geous of them to commit to that curiosity, as doing so is dangerous. Everything she says she says with a breathy voice and the hint of a rising inflection, like "Fragility is what makes people *interesting*," but it's a con-fident breathiness. Watching, I sometimes think she is hot, and I want to have sex like she does, with my nipples rubbed hard and genitals unseen.

I've been having some of the best sex of my life with my partner as of late. When I had sex with Samuel, this was also the best sex of my life, but not just because it was the only sex of my life—it held that distinc-tion for quite a while after I started fucking other people. When I looked at him, I was drawn to his body so intensely that I lost sense of anything but his hand reaching toward my own cock. We had not even undressed, often, before we came. Hooking up then felt like the urgent fulfillment of a desire I did not even know I had, that my language could not name, and that first time, also, that Samuel and I touched, I saw Emmanuelle, her body displayed. Samuel and I both fixed our eyes on her, our excuse

to act. Shadowed and obscured, her genitals could have become or done anything. My own cock was, during those years, equally as incomprehensible to me. I could only rarely bring myself to look at it as I touched it, which I did, often and happily, in order to forget it.

I say "my nipples are on" to my partner to mean that he can play with my tits. "Are your nipples on?" he asks me, because if they are not I find the sensation distracting and painful in an unpleasant way, and he knows to avoid this. I grew tits when I was twenty-eight or so, and before that I never liked to play with my nipples, or to have another person do so. I swatted hands away. I remember Samuel once touching his own nipple while he masturbated, which distracted me. Now it is common but random for me to enjoy the sensation of my nipples being rubbed or pulled, which usually begins as I grab my partner's own nipples, hard at the end of a handful of tit. I don't know, however, whether my nipples will be on or off, whether I'll slide my cock into his pussy or his ass, until I find myself there, back arched and fingers tweaking. That is to say, even today, I do not know my own desires until I inhabit them.

I agree with Emmanuelle that the best way to teach someone about sex is to have it. I saw the theorist and living legend Sandy Stone perform at a conference this past summer. She told a long story, which seemed to be a careful mixture of autobiography and fantasy, about mice and sound. At its end, she explained that she was turned on by loud noise and the touch of her hand against her hand, and as a warehouse filled with a hundred or so people who applauded and cheered, raucous, she rubbed her hands and shook with orgasms. The night before, she had said, "tell me something filthy," and I had told her of my friend fucking her partner's prolapsed anus, shoving it back into the body with her cum inside of it, then prolapsing it again later to suck the cum out. Both of these acts, the aural orgasm and the prolapsed fuck, require a sexual knowledge I do not have.

···

The Emmanuelle of *in Space* is one version of a character that recurs in soft-core pornography, first in the 1967 French novel *Emmanuelle: The Joys of a Woman,* then the 1974 film *Emmanuelle,* notable for showing

a woman smoking a cigarette with her labia, and eventually in a large number of soft-core movies and television shows through the present day. Emmanuelle travels through time and space, battles Dracula, solves crimes, becomes a nun, and fights her way out of a prison. While the different embodiments of the character experience an incredible diversity of life experiences, they almost without exception (sparing cut or rare footage) hold themselves to soft-core pornography's modest conventions. There is no penetration or ejaculation, just the movement of bodies, and the lingering shot always cuts away.

When I say I agree with Emmanuelle that the best way to teach someone about sex is to have it, I am speaking from a very particular experience. That summer when my family got cable television and Cinemax was around the same time, 1995 or 1996, that I was entering puberty. We didn't get access to the internet for several more years, and even then, the available technology meant I could only access written erotica and the occasional photograph. As I also lived in that small town and did not meet so much as a bi-curious girl until I was eighteen (and still then a couple more years passed before I met another trans person), I had a very slim amount of sexual knowledge available to me during my adolescence. Searching on Yahoo! years after Samuel and I stopped blowing each other, I would still not even know what I was looking for, just that I was driven again and again to type in phrases like "bras off" or "boner in basement," phrases that were sexualized without being exactly pornographic, variations on erotic moments from my own life.

What I did have in those years between first having sex and getting online and out of town, however, were two sources of knowledge: straight boys horny enough to fool around with me and soft-core pornography like *Emmanuelle*. Both of these sources of knowledge were defined by silence and obfuscation, which means both were spaces of equal parts reality and imagination, where bodies were able to become all things at once in my feverish and confused longing, I don't know what for.

I know that this difference is not small for people like me, whose genders, whose bodies, and whose desires were unarticulated in the small-town, no-cable world of Middle America, mid-nineties. It might seem disingenuous to call Emmanuelle the first trans person I ever saw,

but that is who she is to me. There were, in the same burst of non-small-town reality, Madonna and Sandra Bernhard flirting on Letterman, and the gay men of early *Real World* episodes, but my young self knew that these people were not me, even as I formed a fractured identification with them—an identification that allowed me to voice a part of myself while further negating so much more. And there, in the middle of it, was Emmanuelle. There her body was multiple, exiled from the explicit and made brilliant in the imaginative, becoming both cock and pussy and neither. There, in the illogic of orgasm, my body became multiple too.

I do not know what it means to see yourself portrayed at that age. I do not even know what words like *trans* might have meant to me, if I might have seen myself in them, found some efficacy in their leveraging. But I do know what it means to be unfixed from narrative, an unfixing that feels something like claiming power. I feel grateful that I was unfixed, really. It meant that I traveled through space as a hotel burned.

...

Emmanuelle in Space has little to do with its own plot, although more happens than in most soft-core porns. For instance, on a yacht on the River Nile, Emmanuelle shape-shifts to see if Haffron can identify her by the ways she fucks, by "her essence," among a number of other women he picks up. She goes to sexual temples around the world, shares different philosophies of pleasure with the aliens, exploits and appropriates traditions about which she is evidently ignorant, and time travels to ancient orgies through her dreams. In this range of human sexuality, lesbian desire is occasional and subsumed to men, and the closest men come to hooking up with each other is a rare moment in which two monks pleasure a powerful visiting princess.

In all of this, Emmanuelle remains the definitive force of power. She wears a lot of high-waisted denim shorts and midriff shirts, and she knows things. In the final episode, as the aliens prepare to leave, they try to make sense of all that has happened. Their thinking is a mixture of the calculated and logical, *what does sex mean to this species,* with wrought, desirous urgency, Emmanuelle and Haffron having fallen in love. "It's very nice when the dream, the ideal, and the reality are the

same, isn't it?" she asks the aliens. All the while, they ponder what it means, that Emmanuelle is single despite fucking so many men, as fucking is at times an expression of love, and she is the best at fucking of all humans. Emmanuelle lets them ponder this and smiles. The aliens throw their questions at her in a way that recalls supplicants beseeching a goddess, were that goddess also intimately known. "I didn't understand that something happening in my mind could be in my heart too, and in the world," one of the aliens declares. Another reveals that he too has fallen in love, although when he did, it was not because of the woman's physical beauty but because of the gorgeous music she played on the piano before they climbed onto it and fucked.

I like to be as entirely in my body as possible when I fuck because my body is an unthinking place. Here is a place where truths obscured by thought live. Sometimes I am not in my body for any number of reasons, because the body is not mine in that moment or because I am drunk or because I have thought of an idea that is very far away. Sometimes not being in my body is a joyous relief. Like a camera cutting away, earlier today I kept closing and then opening my eyes while fucking my partner. I saw my cock in his pussy and it was slimy with my spit, his spit, my cum, his cum. I closed my eyes and thought of two cocks pressed up against an asshole and socks on my partner's feet. The way *Emmanuelle* positions the camera makes it possible to sometimes imagine the cock in the pussy and the asshole at the same time, and as it never confirms which hole is being used, they both stay filled forever. Samuel and I didn't know what to say after we came that first time, and so we just played Mario Kart silently. When I opened my eyes while fucking my partner this afternoon, I always looked directly at our bodies, thought about how it was my cock and his pussy, and sometimes looked into his eyes after. Emmanuelle doesn't answer any of the aliens' questions because the body is the answer. The body is the answer because if you go far enough into it then it ceases to be there at all. The body is the answer because the pursuit of knowledge is the pursuit of not knowing, even if only for one orgasmic second. When I came inside my partner's pussy hard, I don't know what happened, but sounds escaped my mouth and my body, it made music.

Punky Power

Nina McConigley

*I'm Your Only Friend, I'm Not Your Only Friend,
I'm Your Brown Friend*

<u>TEASER</u>

SCENE A

FADE IN:

<u>INT. ST. ANTHONY'S SCHOOL, ANGIE'S HOME – DAY AND NIGHT</u>

A MONTAGE OF ANGIE'S DAY. ANGIE AT HER DESK. ANGIE PLAYING DODGEBALL. ANGIE EATING LUNCH WITH HER GROUP OF FRIENDS. ANGIE PLAYING VOLLEYBALL. ANGIE WALKING HOME. ANGIE HAVING DINNER WITH HER PARENTS. ANGIE ON THE PHONE AT NIGHT TALKING TO HER BEST FRIEND NINA.

<u>NINA</u> LISTENS INTENTLY TO THE CONVERSATION ON HER OWN PHONE. <u>ANGIE</u> HOLDS A SMALL BOX IN HER HAND.

SOUND: PHONE CONVERSATION AND LIGHT ROCK MUSIC PLAYING IN THE BACKGROUND OF ANGIE'S ROOM

So, I got us these necklaces? They're like a little heart, and we both wear one half! At first, I thought maybe I should give the other half to my mom, 'cause we can tell each other anything. But then I was like, no, Nina has to have it. She always knows what to do. You always know what to say. But I also think I could give it to Paula.

NINA SMILES INTO THE PHONE. SHE SAYS NOTHING.

END TEASER

...

I want to be more than friends.

When *Punky Brewster* premiered in 1984, I was eight. The same age as Punky. Punky's real name is Penelope. In the pilot, Punky is living alone in a vacant apartment building with her golden retriever, Brandon. Her father and mother have both abandoned her. Instead of fending off suitors, this modern-day Penelope hides from adults and social workers. She is later found by the building's super, Henry, an old curmudgeon who takes her in. In a kind of poor man's *Annie*, both dog and girl change the life of everyone they meet.

Every episode of *Punky Brewster* revolves around some mishap. Will DCFS get her? Should she play baseball? Will she have a room of her own? And week after week, the person by her side is her best friend, Cherie Johnson.

Cherie is black. She lives with her grandmother, Betty. She wears a lot of headbands. In one ear, she wears a hoop earring, and in the other, a stud. She is practical. She is the Greek chorus behind Punky, commenting on all the main action. She is me—the best friend, the earth revolving around the sun. It is no coincidence the actress who played Punky is named Soleil Moon Frye. The actress who played Cherie Johnson is named Cherie Johnson.

I went to a Catholic school called Saint Anthony's. My fourth-grade class had twenty students in it; I was the only brown one. The most popular girl in our class was named Angie, and I was not her best

friend. That honor went to a girl named Paula. But I was friends with them. I was a third wheel, and often not included at all. It was only after Paula and Angie fell out over an incident at the roller rink that I was promoted.

On so many TV shows, there is the black best friend. Or, that friend is often Asian. "It's going to be O.K."—that's what the friend of color always says. The friend is wise. The friend calls out the main character. The friend usually has little going on in their own life. The friend is sassy or exceedingly good. You never see the friend's house. The friend is flatter than the main character. "It's going to be O.K." Tonto says it to the Lone Ranger. Tootie says it to the girls of Eastland School in *Facts of Life*. Alfonso says it to Ricky in *Silver Spoons*. Reggie says it to Vicki in *Small Wonder*. Elena says it to Felicity in *Felicity*. Renee to Ally McBeal.

When I watched *Punky Brewster*, it was not Punky I studied, it was Cherie. Did Cherie always go along with Punky's schemes? (She did.) Did Cherie mind when Punky played with her other friend, Margaux? (She did not.) How did Cherie dress? (A lot, a lot of headbands.) I emulated Cherie. I wore one hoop earring, one stud. I knew it was my destiny to be like her. She was calm and collected. She didn't go back to her apartment and scream. It was her job to be indispensible to Punky. It was her job to be, as Punky would often say, "A #1."

...

ACT ONE

SCENE B

FADE IN:

INT. EASTRIDGE MALL – DAY

A MALL FOOD COURT. TWO TEEN GIRLS SIT TOGETHER AT A TABLE, DRINKING SODAS AND EATING FRIES.

NINA SIPS HER DRINK. ANGIE ANIMATEDLY TALKS.

SOUND: LIGHT MUSIC AND PEOPLE TALKING

ANGIE

I think John likes me.

NINA

Of course he does. It's going to be O.K.

<u>END ACT ONE</u>

···

Punky has several catchphrases.

"Grossaroo!"

"Holy macanoli!"

"I've got Punky Power!"

When she says them, the audience laughs and laughs. Cherie doesn't really seem to have a catchphrase, except for saying Punky's name in an exaggerated way. The best friend of color often doesn't have their own shtick, or if they do, it's exaggerated comic relief, a wee minstrel show.

Punky declares "Punky Power!" again and again. It is her mantra. And it means believing in yourself and that things are going to be O.K. You can't give up. Almost as if Cherie and Henry's belief in her isn't quite enough. Even Cherie seems to believe in Punky Power; when Punky declares it, she has more gusto for whatever task they are up to.

The best friend of color helps the main character get the guy. The guy (there is always a guy) always likes the main character. The best friend of color has no romantic life of their own. I didn't have my first kiss till I was in college. I watched all my other friends pair up from sixth grade on, and I was, even to the guys, just the friend.

Punky also has two other friends on the show. The first is Margaux Kramer, who is rich and sometimes a nemesis to Punky. And then there is her beleaguered friend, Allen Anderson. Allen is never Punky's boyfriend; he is more like a brother, following Cherie and Punky around. Allen and Margaux are both blond. They are never as close of friends to Punky as Cherie is.

But occasionally, Cherie is given the main story line on the show. In one of my favorite episodes, Punky, Margaux, and Cherie all enter the Miss Adorable pageant. Margaux tells Punky and Cherie the only way to get your parent's love is by winning things—you have to show your worth. Margaux has been on the pageant scene since she was a baby. In the opening slumber-party scene, she sleeps with one of her trophies. Punky is intent on winning. She's sure that if she wins, Henry will see her worth. Cherie only enters the pageant because the host is Andy Gibb. While Margaux and Punky worry about winning, Cherie is cool and collected. For the talent part of the show, she does a magic show. She wears a top hat and makes Andy Gibb disappear. Punky attempts to make Brandon do tricks for her number, and Margaux sings and tap dances. In a surprise move, Cherie wins Miss Adorable. Margaux is incensed. Punky is thrilled for Cherie.

I was so happy when Cherie won. Finally! While Margaux and Punky were bickering, Cherie snuck in and won it. I had the same strategy with Angie. I waited for her and Paula to wear themselves out with their own fights.

I started applying the same strategy to everything, even dodgeball. I would slink around and hang out in the background, and I often was the last one standing: not because I was good at hitting people, but because I was good at staying out of the direct line of fire. Cherie taught me that strategy. You win when you don't have much in the game. When you have no horse in the race.

...

ACT TWO

SCENE C

FADE IN:

INT. ST. ANTHONY'S CATHOLIC SCHOOL – DAY

A LARGE SIXTH-GRADE CLASSROOM FILLED WITH TWENTY DESKS, EACH FILLED WITH KIDS. THEY ARE WEARING UNIFORMS.

NINA SITS ALONE WITH HER DESK OPEN, RUMMAGING INSIDE.
ANGIE TAPS HER ON THE SHOULDER.

SOUND: KIDS TALKING

ANGIE

My parents are getting a divorce.

NINA

It's going to be O.K.

END ACT TWO

...

It wasn't always sunshine and rainbows on *Punky*. A very special episode dealt with big things. You knew it was special because the laugh track was gone. The audience was somber, and there was a warning before the show started. I lived for these episodes. Each was a moment where the screen lifted and you saw Oz. These perfect lives with resolution and laughter were turned off, and for a moment, drugs, pedophilia, kidnapping, death—they all came in.

I loved things with my name on them in the '80s, but it was hard to find them. Nina was not a common name. At the local T-shirt shop, I had T-shirts made with cats and rainbows on them. I picked a design from a wall of transfer decals, then would watch as a feather-haired kid put the shirt between the hot plates while they ironed on whatever I had chosen. I would have my name put on the back in velvety letters. Later, when people became worried about kidnapping and Satanic Panic was prevalent, my mother collected everything with my name on it and put it all away. You couldn't risk a stranger calling out to you, knowing who you were.

In 1986, two years after the show first aired, *Punky Brewster* had a very special episode. In it, Cherie, while playing hide-and-seek, hides in a refrigerator that Henry has left outside the building. She suffocates, unable to open it from the inside. Punky and Margaux perform CPR on her, saving her life. Henry and Allen watch from the sidelines, as Henry

doesn't know CPR and Allen was goofing around in class the day they learned what to do.

When Cherie is pulled from the fridge, her body is limp, and she is laid out on the snow like an angel. Punky is calm. "Look, listen, feel," Punky instructs. She opens Cherie's airway. She gives her mouth-to-mouth. One one thousand, two one thousand, three one thousand, four one thousand. She breathes into her mouth while Margaux does chest compressions. Cherie slowly comes back to life. Cherie's grandmother, Betty, who she lives with, is a nurse, but is not to be found until Cherie is already conscious.

I loved this episode. Danger could be found at any time, any place. When you were at the mall wearing a shirt with your name on it, when you were playing in an abandoned fridge. But what I loved most was the horror of Cherie almost dying. What would Punky have done without Cherie? She needed her.

My sister and I reenacted the refrigerator episode with a cardboard box. My sister pulled me out and pretended to do CPR. But then she decided I wasn't good at being unconscious, and so she played Cherie. I wondered if Angie or Paula would save me if, say, I cracked my head open at the roller rink, or was kidnapped while I waited for my mom after school. My sense was no. In one episode of *Punky*, Punky, Margaux, and Cherie become ketchup sisters. Instead of cutting their fingers, they put ketchup on them and all rub them together. Punky declares ketchup thicker than water and that they are bound for life. When I told my sister about this episode, and how Angie and Paula would never be ketchup sisters with me, she hauled me into the bathroom. Taking a razor blade out of the medicine cabinet, she cut both of our fingers and rubbed them together. "There! We're blood sisters!" she declared. It didn't even occur to us that we'd been blood sisters from the moment I was born.

...

ACT THREE

SCENE D

FADE IN:

EXT. ST. ANTHONY'S SCHOOL PLAYGROUND – DAY

A LARGE FOURTH-GRADE CLASSROOM FILLED WITH TWENTY
DESKS, EACH FILLED WITH KIDS. THEY ARE WEARING UNIFORMS.

NINA SITS ON A BENCH NEAR THE MAIN BUILDING. ANGIE
APPROACHES HER FROM THE SCHOOL AND REMAINS STANDING.

SOUND: KIDS PLAYING

ANGIE

I got my period.

NINA

You're a woman now! It's going to be O.K.

END ACT THREE

...

The best friend of color seems to develop later. They have their stories, but they are never in the forefront. I watched *Punky* regularly for three years, but by 1988, the last year the show was on, I was less interested. But there was one episode that last season I liked a lot: "Dear Diary." In it, Punky finds Cherie's diary and sees that Cherie has talked smack about her. But later, she learns the diary is fake, an attempt to teach Punky a lesson about nosiness. I thought a fake diary was an ingenious idea and made one too. The only thing was, I didn't have anyone who cared enough to find a fake diary. Angie was no Punky. Cherie taught me to find a person and to become vital to them. But what I didn't notice till much later was that while Cherie may have been the best friend of color, Punky was also an odd duck. She wore weird clothes and was an orphan. She and Cherie were both motherless. And perhaps their own oddness and otherness brought them together. Angie and

Paula were popular. It was no wonder I never really was a good friend to either one of them.

By the time the show went off the air, I was more interested in darker things. Punky and Cherie selling Lady Contempo makeup door to door or going to camp seemed less appealing than Margaret in Judy Blume novels. I was more attracted to watching shows like *A Different World*, because (a) Lisa Bonet wore awesome clothes and (b) I was fascinated with a school that was pretty much all people of color.

It's funny because both *The Cosby Show* and *A Different World* subvert the brown-friend role. Denise Huxtable has Maggie Lauten, played by Marisa Tomei. And Cliff Huxtable's best friend is Jeffrey Engels, played by Wallace Shawn. As white best friends, they seem to be a little hapless. Jeffrey and Cliff have a falling out when Cliff loses his power drill—high drama for *The Cosby Show*. Maggie Lauten dates a boy who works at the National Pork Council, and one episode focuses on her painful play adaptation of Adam and Eve, which Denise performs in. But poor Cherie Johnson. After playing the best friend in eighty-five episodes of *Punky Brewster,* she would go on to spend fifty-nine episodes as Maxine Johnson (why did she always keep her last name?), the best friend to Laura Winslow, on *Family Matters.* At least Laura was of color. Cherie Johnson now is a writer and has published four books. One of them is a novel called *Peaches & Cream,* another a book of poetry. She is telling her own story.

As a kid in the '80s, I was happy to see any brown kids on TV. But I wanted to be the sun. I wanted to believe in Punky Power. I wanted to break out of the refrigerator and see the light.

Sick, Sad World
Watching *Daria* in 2016

Danielle Evans

I must have seen my first episode of *Daria* by accident. I still watched MTV for music videos back then, and beyond knowing what time TRL came on, its programming schedule was mysterious to me. I wouldn't have gone looking for *Daria*. There were only five ironclad rules in my house growing up: no Kool-Aid, no Froot Loops, no saying "sucks," no *Simpsons,* and no *Beavis and Butt-Head.* Though I was home alone most afternoons and it would have been easy enough to watch whatever I wanted, and my mother would have been unlikely to connect *Daria* to its source material anyway, my first instinct was to avoid it. All I knew about the show was that it was a spin-off, and if *Daria* had wandered off from the world of *Beavis and Butt-Head,* a show beloved by the class-mates I liked least, then obviously *Daria* was not for me.

It only took the introductory theme song to convince me I had been wrong. I couldn't resist a song that growled politely, that said *excuse me* before closing with *you're standing on my neck.* How much of being a teenage girl was working up the nerve to tell someone—gently enough that you would be heard, fiercely enough that you might be listened

to—that they were hurting you? I loved it. I loved the title character, Daria Morgendorffer, smart and cynical and defensively misanthropic, often toeing the line between right and self-righteous. I loved her best friend, Jane Lane, who was an artist, who always had her back, who rocked amazing red lipstick. I loved Daria's little sister, Quinn, whose shallowness was often a punchline, but whom you could tell the show still loved. I loved that Quinn, who spent half of high school in a battle of brilliant passive-aggression with her best frenemy Sandi, the president of the fashion club, and the other half strategically dating for social leverage, could have been played as stupid, but emerged instead as a tactical genius of sorts. I loved that Daria, whose primary identity was wrapped up in being a "brain," could be stupid sometimes, could turn to mush around Jane's musician older brother, Trent, who made her go uncharacteristically silent for the better part of one season and talked her into a belly-button piercing in another. I loved that Daria could in later seasons miss the signs that she was falling for Jane's boyfriend until it was too late to change course. I love the show's sense of humor, its penchant for a well-placed literary reference, and the amount of time Daria and Jane devoted to watching *Sick, Sad World,* a tabloid news show that drummed up unrealistic fears in a way that read more obviously as satire in 1997 than it does now.

Most of all, though, I loved Jodie Landon. Jodie was Lawndale High School's overachiever-in-chief. She was valedictorian, a member of the student council, the yearbook editor, and the homecoming queen for years in a row. She was also, like me, a black girl, a fact that the show neither avoided confronting nor let stand as the only fact about her. Jodie was friendly with Daria and Jane but not especially close to them. She was a background character, featured in quite a number of episodes but playing a significant plot role in only a few. She was troubled by injustice but could be ruthlessly pragmatic at times, which in some episodes created tension between her and Daria, and in others let her serve as an effective reminder to Daria that the choice to opt out of playing along and trying to be likable was a choice requiring privilege that, for all her parents' financial success, Jodie lacked. In one episode, she labeled herself "queen of the negroes" when describing the pressure she felt to be a

model student at their suburban high school where there were few other black kids, and in another, she fought with Daria over name-dropping her wealthy father's name at a bank in order to avoid being dismissed for discriminatory reasons the way she had been at a previous bank.

In the world of '90s black sidekicks, Jodie was a revelation. There were, of course, complex black female characters on television in the '80s and '90s, but they were by and large on shows where all of the primary characters were black. Some of them were excellent shows, but it was as though television believed that black people could only be interesting in the absence of whiteness. Black friends on primarily white shows were typically happy sidekicks or funny stereotypes or characters who appeared for very special episodes during February sweeps for just long enough to be racismed against or dated or both, in plotlines meant to underscore how far we'd come. By the middle of the 'oos these very-special-episode friends would fade, but they were often replaced by a kind of equally problematic racelessness, a world of black series regulars whose race was never commented upon or scripted for.

In 2016's television landscape, which has given us television where black people can be black and interesting at the same time even when there are white characters around, Jodie might read as underdeveloped, but in 1997 she was a gift. *Daria* didn't spend all of Jodie's screen time focusing on race—sometimes she just got to have high school problems that weren't specific to blackness—and when it did focus on race it got a lot of things right. Jodie's plotlines were often graced with subtlety: in one episode, she and her boyfriend, Mack, are on a parade float, lamenting that their classmates have elected them homecoming king and queen for the second year in a row, in what feels to them like a self-congratulatory attempt to prove Lawndale isn't racist. Jodie decides she isn't going to wave anymore, and seems on the edge of a larger declaration about refusing to perform gratitude, when she sees in the crowd of mostly white faces a black family whose young daughter is beaming at her. Jodie stands, smiles, waves at the child, and quietly remembers why she's jumped through all of the hoops. The whole scene was over in under a minute, but watching Jodie made it feel like someone on *Daria*'s writing staff was, or had at least met, a black person. Jodie was friendly.

Jodie was accomplished. Jodie was polished. Jodie was lonely. Jodie was exhausted.

...

Here is the essay this was going to be: I wanted to think about race and gender and performance. I wanted to think about how clearly draining Jodie's performance of nonthreatening perfection was, and how few people other than Daria and Jane seemed to realize that. I wanted to think about the pushback Daria got for not being willing to play along, and the pushback Quinn got for understanding all of the rules for being a teenage girl and playing the game too well. I wanted to think about race and gender and rules and performance in the context of U.S. politics, specifically in the context of the 2016 presidential election. I wanted to think about the ways in which the country demands a kind of cheerful going-along from Obama but doesn't always recognize that cheerful going-along as performance, because it is so often what is demanded of black people before white people will listen to us at all. I wanted to think about the ways that pressure has shaped and limited Obama's presidency, and about the trap it set for Hillary Clinton: the ways in which a refusal by some Americans to recognize how and why Obama is performing for us made it all the more obvious the ways in which Hillary Clinton was performing, had to be performing, because what we often demand of women if they want to be rewarded is the same kind of obvious performance for which we later punish them.

I was writing that essay in the space of an election where the white male candidate seemed to have finally taken himself out of the running, when, after months of open racism and unconstitutional threats, he was caught on tape bragging that he could get away with "[grabbing women] by the pussy." So, I wanted to think about the shape of a Hillary Clinton presidency. I wanted to think about how we recognize the traps set for women in politics without letting that silence us about real issues. I wanted to think about the ways in which when she was performing a version of herself, Hillary Clinton was also performing a version of the '90s that didn't quite happen. I wanted to think about what it meant to

apply the rhetoric of peace and prosperity to that era in a way that erased the communities for whom the '90s were not peaceful. I wanted to think about welfare reform and the crime bill and the language used to sell them; I wanted to think about what that did to the wealth gap, and how it destabilized the black middle class, how it sold a version of cultural pathology that even some so-called progressives were comfortable with, even though it was so easily repackaged into the virulent and factually baseless brand of white supremacy Trump eventually ran on, and how the whole time so many black people on TV, even on the shows that were for and by and about black people, were selling us a narrative of forward motion. I wanted to think about the ways I am always writing about these kinds of performances: the space that fiction has and TV doesn't always is the space to write the gaps between public selves and private selves, to contrast public narratives and private narratives. I wanted not to think about the lie I was telling myself: that in a few weeks I'd be in a world where I didn't have to think about Donald Trump, or the people who would have him be president.

···

Election day in 2016 was on my thirty-third birthday, and so I had the nerve to have a birthday party. The second-to-last guest to leave was a colleague of mine, another woman of color, a person I am used to seeing calm when I am feeling hyperbolic, and just after the election was called, she turned to me and said, "Do they really want us dead?" and I don't remember exactly how I answered, but I remember feeling like the answer was yes, that my country had just voted against my continued existence and hers too.

By the time the last of my sad party guests went home, it was not my birthday anymore, but I was still thinking of my mother. I am always thinking of my mother on my birthday, because on the day I was born, my mother was in labor for twenty-three hours, and it always seems to me I should spend all day on the anniversary of that begging for her forgiveness. Although intellectually I understand that difficult labor isn't a choice, nor is it a choice whether or not it ends well, emotionally I sometimes cling to this fact as a truth about myself and my lineage. The

world is brutal, but I come from stubborn women. The world is brutal, but I came into the world difficult and was not meant to learn to be easy.

I was also thinking of my mother because I was looking at her picture. I had a 6:00 a.m. flight to New York for my aunt's funeral, and because it would have been futile to try to sleep at that point, I stayed up packing and repacking. There is a picture of my mother that I travel with lately, a picture taken a few months after I was born. I am in a stroller, and the sun is shining on us, and my mother is twenty-six and beaming. I'm not sure how the picture wound up in my suitcase the first time, but my mother was in the hospital when I found it, and it seemed like a sign to find this picture of her smiling, seemed like a thing I should hold on to, and so I keep packing and repacking it, and while I moved my things from a big suitcase to a smaller one for the New York trip, the photo turned up again.

On election night, I looked at the picture and thought of how young my mother was then, how young she was when she had me. While she was pregnant with me, my mother worked for the Justice Department's Civil Rights Division. Her first case involved school disparities in Louisiana, and required her to travel between D.C. and Pointe Coupee Parish, to try to enforce a desegregation order that had first been issued nearly twenty years earlier. My mother, twenty-five and baby-faced, at first trying to conceal her pregnancy and then too hugely pregnant to hide it, was greeted by the NAACP chapter president with the exclamation, "You're the Justice Department?!" She was followed to an NAACP meeting once by white school-board members who were also rumored Klan members, who carried shotguns and demanded entrance to the meeting, and my pregnant mother stood outside and told them no. Her work helped get the Parish's high school new textbooks and science equipment. The NAACP chapter president came to be a family friend. And while this was a story of my mother's strength more than labor was, I confess that in those hours after the election it did not make me feel stronger. It made me feel furious and broken on her behalf. What kind of world tells a woman she can change it, can bring a baby into it even, and then breaks all its promises? What kind of country lets the Klan follow a pregnant woman around and thirty-three years later tells her

child it resents every step she's taken forward? I felt a grief for the progress I'd believed in, an anger that I'd believed in it at all.

For a few days, that fury was a screen between me and everything. I went to the airport sleepless and dressed to go straight to the funeral service when I landed on the other end, thinking of my aunt's death and all the time that had passed and all the time that obviously hadn't. I stood in the security line and said whatever the agnostic version of a blessing is for the TSA agent whose job it was to move through the line making small talk, who chatted with the couple in front of me about their vacation, then took one look at my face and moved on to the couple behind me, because I could not have answered then a question as simple as how I was or where I was going, and it must have showed.

I sat in the waiting area for the plane and did not talk to anyone and hoped that no one would make small talk with me. The only other woman of color on the flight sat down next to me, and I smiled at her, and it occurred to me that I had been unfriendly all morning, that I had declined to make small talk with the cab driver, that I would not look up at strangers, that the aftermath of the election would make me wonder if I might have already met all of the white people I could risk knowing, would make me afraid of any conversation that would lead to the election, which would lead to Trump, which would lead to me realizing how many of my neighbors had found it hard all along to see me as human, or at least easy not to try to. But the first person to cry when the airport TV repeated the election results was an older white woman. I felt a new wave of anger; I had been so consumed grieving the coming loss of civil rights that I had not yet sat with what we had already lost by electing a man so proudly sexist and openly contemptuous of women, what it meant for women who'd lived through decades of similarly disgusting bosses and bullies and predators to watch Trump triumph.

I could not talk to strangers for days. I was glad to see my family, though as we attended fellowship for my aunt in the church across the street from the projects where my father and his sisters grew up, not more than a few miles from the Westchester condo tower Trump built a decade ago, I remembered all his comments about inner cities as places where there was nothing to lose. Come and see this, I wanted to say to

someone, but I also did not want anyone to see it, to see my close-knit family or the friends they had known since childhood, to look at love and grief and reunion and see only an audition for potential humanity, or worse yet, to see nothing at all. I spent the night at my cousin's house, and as we sat in his living room every so often he would look up and say, "Donald Trump is going to be the president," and then shake his head, and I would look back in a similar state of disbelief. On the way back home I was distant to everyone, even a very friendly woman who complimented my shoes, and as soon as I got back, I crawled under a blanket with my laptop and started to rewatch the rest of *Daria*. I was no longer writing the essay I'd been writing, and no longer certain I could write any essay at all, but in a moment when I felt capable of very little, I felt capable of watching *Daria* like it was my job.

...

The series finale of *Daria* is a made-for-TV movie titled *Is It College Yet?* The end of season 5 was originally supposed to be the end of the series, meaning much of what *Is It College Yet?* ties up would have gone unresolved had it been up to the series creators and not MTV. Daria gets into a very good school and is wait-listed at the more prestigious school where her boyfriend, Tom, whose family has gone there for generations, is admitted. Jane, who is a brilliant artist but has never had great grades, is rejected from both local colleges she applied to and struggles to put together a portfolio, all the while wrestling with whether or not she actually wants to apply to art school, which her brother tells her is a form of selling out. Quinn is not leaving high school yet, but gets a glimpse of college life through a friendship with a struggling coworker at the job her parents force her to take, which gives her enough perspective to mildly stand up to Sandy, leading to the breakup and near-immediate reconciliation of the fashion club. Jodie spends the episode wrestling with the decision between Crestmore, the elite college that she and her parents have spent most of her high school career preparing her for, and Turner, the historically black college that Jodie's father and grandmother attended, which her parents don't even know she applied to. Jodie wants to go to Turner but can't find a way to tell her parents; while

she is preparing herself to go to Crestmore, Mack speaks to her father on her behalf.

Jodie's plotline in the finale is significant in terms of the amount of time it gets, but for something that represents a major redirect for the character we've seen working toward the Crestmore goal for years, it feels slightly underdeveloped. Other than legacy, Jodie doesn't make much of an affirmative case for Turner—her faith is mostly that it's not Crestmore, that it's not Lawndale, that it will thus give her a break from the expansive whiteness that has been her life to date. It's not hard for me to believe that a character in Jodie's position would consider an HBCU, but I was unconvinced that her motivation had been developed enough. I didn't know then and don't know now whether the show couldn't come up with a concrete positive argument for being in a black environment, or whether it was the intention of the writers to say that escape was reason enough.

...

Some things that happened while I was rewatching *Daria:* Trump appointed as his chief strategist a man who ran a platform that had been a hub for white supremacy; Trump interviewed for cabinet positions a man best known for pushing anti-immigrant legislation and laws making it harder for people to vote, and a man who fought against HUD's housing initiatives; Trump appointed as attorney general, head of the department that sent my mother to Louisiana all those years ago, a man who was skeptical of the Voting Rights Act and had years before been deemed by a senate committee to be too racist to be a federal judge; Nazis held a conference in D.C., declared Trump's incoming administration a best-case scenario, and took pictures giving the Nazi salute in the Italian restaurant where I had dinner with my father the night of Obama's 2008 inauguration ball; Trump publicly demanded that performers from the show *Hamilton* apologize for making a moderate statement asserting their fear of the policies of Vice President-Elect Mike Pence; Trump agreed to pay a $25-million settlement for running a fraudulent university that targeted and scammed the most economically vulnerable; there was an uptick in hate crimes across the country, including

threats, beatings, and swastikas on playgrounds; Trump summoned a group of television reporters and yelled at them for unflattering reporting; Melania Trump decided to remain in Trump Tower, requiring the Secret Service to move in and pay rent to the Trump Organization; two white women lost their jobs for commenting that it would be wonderful to have a classy first lady again and calling Michelle Obama an ape.

These things scared me, but they did not hurt as much as the other thing that happened in those weeks: supposed liberals and progressives determining, before the numbers were in, before it was clear that Clinton won the popular vote by millions of votes and lost the three determinative states by about a hundred thousand votes combined, that the lesson of the election was to abandon identity politics, in which *identity politics* seemed to mean the difficult work of standing up for the idea that their nonwhite and LGBT friends are fully human.

I live in Wisconsin, a state that (pending the official recount now in progress) flipped from Democratic to Republican in the presidential race by less than thirty thousand votes. It happens to be a state where the economic and criminal-justice disparities between white citizens and black and native citizens are unusually bad even for the United States. It's a state that, according to recent court rulings, has so gerrymandered its legislative districts to privilege white rural voters over urban centers that it is actually unconstitutional, in the same year that its attempts to restrict voter eligibility also got it reprimanded by the court, creating both more cumbersome ID standards and early-voting practices, as well as enormous confusion about what the rules in fact were.

It was apparently not identity politics that voters in Wisconsin twice (three times if they voted in the recall election) voted for Scott Walker, a man who fought against unions, public-sector jobs, teachers, and professors; rejected Obamacare subsidies; made no secret of his corporate allegiances except when he was dragged into court over them; failed to balance the budget; drove public school teachers out of the state; met none of his job-creation targets; and knocked down the ranking of the state's flagship research university.

Most Trump voters are not attending neo-Nazi conferences. But a person who believes in open-carry and would call it tyranny if police

policy in their neighborhood allowed officers to shoot at the first sign of trouble and ask questions later, but just happens to think that every time an unarmed black person is shot the police should get the benefit of the doubt, even when the victim is a child, even when there is a tape, holds some beliefs about who deserves the full rights of citizenship, perhaps even about who is fully human. A person who thinks the government was right to let armed protestors take over a federal bird sanctuary and then acquit them, but is also right to spray Standing Rock protestors with rubber bullets and water cannons until they get out of the way of the oil pipeline that was rerouted to avoid Bismarck, has a belief about who has certain legal and human rights in this country, whether or not it is articulated as such. A person who believes in entitlement programs as long as they're not going to too many blacks or immigrants or natives is expressing a belief about who deserves to live and who deserves to die. A person who believes in a ban on Muslim refugees for "safety" thinks only some groups are human enough to deserve safety. A person who thinks the threat to their children's higher education is not the defunding of public schools, but instead that they may be required to take an ethnic-studies course and be in classes with students who find their language insensitive, is worried about a loss of cultural power, not a loss of economic power. That these views are treated as normal enough to escape labeling is a function of how deeply invested this country is white identity.

I do not expect to walk outside in a month and find my neighbors who voted for Trump heiling Hitler. What scares me is the traction of the underlying beliefs, the possibility that if the open white supremacists were to go door to door with a ten-point plan and avoid using the word *Nazi,* they'd get a lot of signatures. What scares me is how many people would, no matter the language they use to describe their beliefs, reserve the full rights of citizenship only for white Americans and a handful of people who are willing to perform for them and prove they're the right kind of other. I got to the end of *Daria* and wanted to keep hiding. I wanted to disengage. I wanted the awfulness of the world to be a distant joke. But black girls don't get to be Daria, even *Daria* knew that.

...

Daria is iconic for its representation of adolescent jadedness, so much so that I forgot until rewatching how much of a growth arc the series gave its title character. The takeaway from Daria is not, in fact, that the world is unbearably awful, but that the world wasn't quite as bad as she made it out to be. In the later seasons of *Daria,* she's able to appreciate her parents and even thank them for handling the challenge of raising her. She and Quinn occasionally venture into open kindness and expressions of respect and encouragement. She takes Jane's and Jodie's advice to give people a chance more often. After seasons of moping around Trent, the kind of guy who would never be genuinely available even if he wanted to be, she negotiates her first real romantic relationship with Tom, talking it through when her instinct to run at the first sign of trouble kicks in, and then maturely ending things when it becomes clear the relationship is really over. She and Jane model for each other what support and closeness look like, even when they're angry. The series ends with them preparing to brave the world together, just after Daria wins an academic award and ends up giving a sincere speech about surviving high school.

Daria's ending was that she got to trust the world enough to be a little bit more vulnerable, which makes it all the more interesting that Jodie's ending was that she got what she hoped would be a break from being vulnerable. I don't know if the show was being deliberate in signaling that despite appearances to the contrary, Lawndale was harder on Jodie than it was on Daria. But the show was explicit that Jodie's parents expected her to take a different path than theirs, that they had been moving in a direction they thought of as forward. There were no very special episodes of *Daria,* there was no one incident that clarified for Jodie that she would feel isolated forever, but there was in the writing of her some acknowledgment that living your life as an audition for acceptance and approval is exhausting. In 2002 I didn't quite buy that Jodie was that exhausted by the path she'd set out on. In 2016 I had less trouble with it. It seemed entirely plausible to me that more than wanting what she'd spent years working for, Jodie might just want to wake up somewhere it felt safe to drop the act.

Contributors

Rumaan Alam's writing has appeared in the *New York Times, New York* magazine, the *Wall Street Journal, Buzzfeed,* the *New Republic,* and elsewhere. He is the author of the novel *Rich and Pretty;* his novel *That Kind of Mother* will be published in 2018.

Danielle Evans is the author of the story collection *Before You Suffocate Your Own Fool Self,* winner of the PEN/Robert W. Bingham Prize, the Hurston/ Wright Award, and the Paterson Prize, and a National Book Foundation 5 under 35 selection. Her stories have appeared in magazines and anthologies including the *Paris Review, A Public Space, American Short Fiction, Callaloo, New Stories from the South,* and *The Best American Short Stories.* She teaches creative writing at the University of Wisconsin–Madison.

T Clutch Fleischmann is the author of *Syzygy, Beauty* (Sarabande) and the curator of *Body Forms* (Essay Press). A nonfiction editor at *DIAGRAM* and contributing editor at *Essay Daily,* they currently live in Chicago.

Elisa Gabbert is a poet and essayist and the author of three collections: *L'Heure Bleue, or the Judy Poems* (Black Ocean 2016), *The Self Unstable* (Black Ocean 2013), and *The French Exit* (Birds LLC 2010). Her work has appeared in the *New Yorker, Boston Review, Pacific Standard, Guernica,* the *Awl, Electric Literature,* the *Harvard Review, Threepenny Review, Real Life, Catapult, Jubilat, DIAGRAM,* and many others. Learn more at elisagabbert.com.

V. V. Ganeshananthan's debut novel, *Love Marriage,* was long-listed for the Orange Prize and chosen as one of *Washington Post Book World*'s Best of 2008. A recipient of fellowships from the NEA and the Radcliffe Institute, she has been visiting faculty at the University of Michigan and the Iowa Writers' Workshop and presently teaches in the MFA program at the University of Minnesota. Her work has appeared in the *Washington Post* and the *New York Times,* among others. She is at work on a second novel, excerpts of which have appeared in *Granta, Ploughshares,* and *The Best American Nonrequired Reading.*

Jenny Hendrix's work has appeared in publications including the *Believer, Orion,* and the *Boston Review* and has been the recipient of a Pushcart Prize. A native of Whidbey Island, Washington, she currently lives in Brooklyn, New York, where she writes about books, makes things into pesto, and misses the mountains pretty bad.

Edan Lepucki is the *New York Times* best-selling author of the novels *California* and *Woman No. 17.*

Nina McConigley was born in Singapore and raised in Wyoming. She earned her MA from the University of Wyoming and her MFA from the University of Houston. Her short story collection *Cowboys and East Indians* was the winner of the 2014 PEN Open Book Award and a High Plains Book Award. She teaches at the University of Wyoming.

Elena Passarello is the author of two essay collections, *Let Me Clear My Throat* and *Animals Strike Curious Poses,* the latter of which was a *New*

York Times Editor's Choice and is forthcoming in German, Italian, and UK editions. Her essays on performance, pop culture, and the natural world recently appeared in *Oxford American, Virginia Quarterly Review, Paris Review Daily,* and the *New York Times,* as well as in two previous Coffee House Press anthologies: *How We Speak to One Another* and *Cat Is Art Spelled Wrong.* She is the recipient of a 2015 Whiting Award, and she teaches at Oregon State University.

Justin Taylor is the author of *Flings, The Gospel of Anarchy,* and *Everything Here Is the Best Thing Ever.* His work has appeared in the *New Yorker, N+1, Harper's,* and the *Sewanee Review.* He is the fiction editor at the *Literary Review* and lives in Portland, OR, and @my19thcentury.

Justin Torres's first novel *We the Animals,* a national best seller, has been translated into fifteen languages and is currently being adapted into a feature film.

Ryan Van Meter is the author of the essay collection *If You Knew Then What I Know Now,* published by Sarabande Books. His work has appeared in journals and has also been selected for anthologies including *The Best American Essays* and *Touchstone Anthology of Contemporary Creative Nonfiction.* He lives in California where he is an associate professor at the University of San Francisco.

LITERATURE
is not the same thing as
PUBLISHING

Coffee House Press began as a small letterpress operation in 1972 and has grown into an internationally renowned nonprofit publisher of literary fiction, essay, poetry, and other work that doesn't fit neatly into genre categories.

Coffee House is both a publisher and an arts organization. Through our *Books in Action* program and publications, we've become interdisciplinary collaborators and incubators for new work and audience experiences. Our vision for the future is one where a publisher is a catalyst and connector.

Funder Acknowledgments

Coffee House Press is an internationally renowned independent book publisher and arts nonprofit based in Minneapolis, MN; through its literary publications and *Books in Action* program, Coffee House acts as a catalyst and connector—between authors and readers, ideas and resources, creativity and community, inspiration and action.

Coffee House Press books are made possible through the generous support of grants and donations from corporations, state and federal grant programs, family foundations, and the many individuals who believe in the transformational power of literature. This activity is made possible by the voters of Minnesota through a Minnesota State Arts Board Operating Support grant, thanks to the legislative appropriation from the arts and cultural heritage fund. Coffee House also receives major operating support from the Amazon Literary Partnership, the Jerome Foundation, The McKnight Foundation, Target Foundation, and the National Endowment for the Arts (NEA). To find out more about how NEA grants impact individuals and communities, visit www.arts.gov.

Coffee House Press receives additional support from the Elmer L. & Eleanor J. Andersen Foundation; the David & Mary Anderson Family Foundation; the Buuck Family Foundation; Fredrikson & Byron, P.A.; Dorsey & Whitney LLP; the Fringe Foundation; Kenneth Koch Literary Estate; the Knight Foundation; the Rehael Fund of the Minneapolis Foundation; the Matching Grant Program Fund of the Minneapolis Foundation; Mr. Pancks' Fund in memory of Graham Kimpton; the Schwab Charitable Fund; Schwegman, Lundberg & Woessner, P.A.; the U.S. Bank Foundation; VSA Minnesota for the Metropolitan Regional Arts Council; and the Woessner Freeman Family Foundation in honor of Allan Kornblum.

The Publisher's Circle of Coffee House Press

Publisher's Circle members make significant contributions to Coffee House Press's annual giving campaign. Understanding that a strong financial base is necessary for the press to meet the challenges and opportunities that arise each year, this group plays a crucial part in the success of Coffee House's mission.

Recent Publisher's Circle members include many anonymous donors, Suzanne Allen, Patricia A. Beithon, Bill Berkson & Connie Lewallen, E. Thomas Binger & Rebecca Rand Fund of the Minneapolis Foundation, Robert & Gail Buuck, Claire Casey, Louise Copeland, Jane Dalrymple-Hollo, Ruth Stricker Dayton, Jennifer Kwon Dobbs & Stefan Liess, Mary Ebert & Paul Stembler, Chris Fischbach & Katie Dublinski, Kaywin Feldman & Jim Lutz, Sally French, Jocelyn Hale & Glenn Miller, the Rehael Fund-Roger Hale/Nor Hall of the Minneapolis Foundation, Randy Hartten & Ron Lotz, Dylan Hicks & Nina Hale, Jeffrey Hom, Carl & Heidi Horsch, Amy L. Hubbard & Geoffrey J. Kehoe Fund, Kenneth Kahn & Susan Dicker, Stephen & Isabel Keating, Kenneth Koch Literary Estate, Allan & Cinda Kornblum, Leslie Larson Maheras, Lenfestey Family Foundation, Sarah Lutman & Rob Rudolph, the Carol & Aaron Mack Charitable Fund of the Minneapolis Foundation, George & Olga Mack, Joshua Mack & Ron Warren, Gillian McCain, Mary & Malcolm McDermid, Sjur Midness & Briar Andresen, Maureen Millea Smith & Daniel Smith, Peter Nelson & Jennifer Swenson, Marc Porter & James Hennessy, Enrique Olivarez, Jr. & Jennifer Komar, Alan Polsky, Robin Preble, Jeffrey Scherer, Jeffrey Sugerman & Sarah Schultz, Alexis Scott, Nan G. & Stephen C. Swid, Patricia Tilton, Stu Wilson & Melissa Barker, Warren D. Woessner & Iris C. Freeman, Margaret Wurtele, Joanne Von Blon, and Wayne P. Zink & Christopher Schout.

For more information about the Publisher's Circle and other ways to support Coffee House Press books, authors, and activities, please visit www.coffeehousepress.org/support or contact us at info@coffeehousepress.org.

Little Boxes was designed by Bookmobile Design & Digital Publisher Services. Text is set in Minion Pro.